HANDWRITING

OF THE TWENTIETH CENTURY

Rosemary Sassoon

Grammar

Battle	Noun Abs. 3rd per. Sing. num. Nom. Case to "was won".
of	Prep. governing the noun "Naseby"
Naseby	Prop. noun 3rd per. Sing. num. neuter gen. Objective Case after "of."
was	Aux. Verb indicating Passive Voice to the principal Verb "won."
was won	Verb. irreg. trans. indic. mood Past tense 3rd per. Sing. num. agree. with the noun "Battle."
by	Prep. governing the N. "Cromwell"
Cromwell	Prop. noun 3rd per. Sing. num. Mas. gen. Object. Case

WHY CHARLES WAS FORCED TO CALL PARLIAMENT
IN 1640 AND HOW RELATIONS DETERIORATED
INTO CIVIL WAR

Charles called Wentworth back from Ireland
so he could be advised about the
Puritans as they were demanding rights
+thought they were being converted to

The changing face of school books as illustrated by these two exercise books written a century apart.

HANDWRITING

OF THE TWENTIETH CENTURY

Rosemary Sassoon

intellect Bristol, UK / Chicago, USA

First Published in the UK in 2007 by
Intellect Books, PO Box 862, Bristol BS99 1DE, UK

First published in the USA in 2007 by
Intellect Books, The University of Chicago Press, 1427 E. 60th Street, Chicago,
IL 60637, USA

A catalogue record for this book is available from the British Library.

Cover Design: Gabriel Solomons
Typesetting: Pardoe Blacker Ltd, Lingfield, Surrey

ISBN 978–1-84150–178–9

Printed and bound by Gutenberg Press, Malta.

Contents

ACKNOWLEDGEMENTS

I would like to thank the many people who have given advice, shared reminiscences and provided samples of their own or other people's handwriting. The publishers and authors who have given permission for me to use their model or illustrations are all acknowledged on the pages that they appear. I would like to thank others too: Jon Tacey of Philip and Tacey and John Handforth of Macmillan for valuable information from their archives, Peter Foden and the Oxford University Press for access to their archives, Dr Elizabeth James and Christopher Skelton-Foord of the British Library and James Mosely of the St Bride Printing Library; also Alec Jackson of the National Arts Educational Archive and Professor John Swift, for information about Marion Richardson, and Philip Poole who provided so many useful copybooks. Special thanks to Nan Jay Barchowsky for all her help on US handwriting, and Kathleen Strange and Paul Green-Armytage for invaluable access to their collections. I would like to thank my husband John for his invaluable support and assistance, and my editor Helen Fairlie for her expertise, and encouragement. Most important of all I am so grateful for the help given to the whole project by Michael Blacker, not only in designing the book but also in advising and visually editing while we waded through the piles of material to produce the complex pages of illustrations.

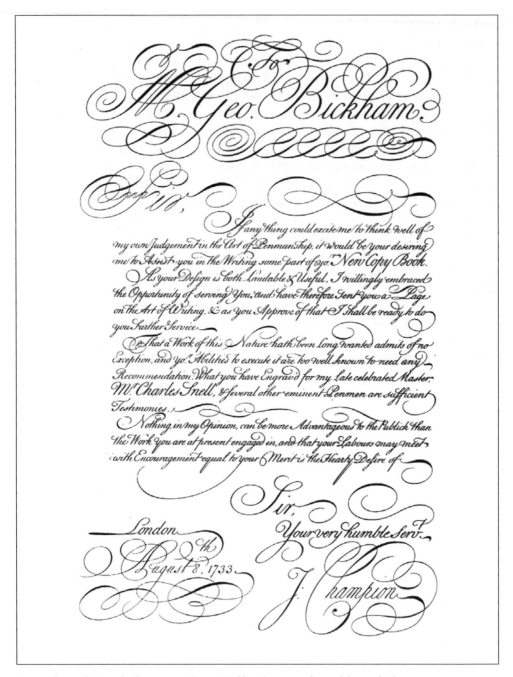

A contribution by Joseph Champion to George Bickham's compendium of the work of contemporary English writing masters, The Universal Penman, *produced in 1733.*

Introduction

T HE HISTORY OF FORMAL CALLIGRAPHY has been thoroughly documented, and the demise of what people see as beautiful handwriting is frequently deplored, but the details of the teaching of this skill during this century have gone almost unrecorded. Everyday handwriting is ephemeral and school books soon disappear. It seemed important to write this history while those who learned to write at the beginning of the century, or taught the subject soon afterwards, can still tell of their experiences. The main purpose of this book is to create a historical record, however, techniques are illustrated that may be useful for teachers today, while the ever-changing views of the stylists provide examples, as well as a warning, to those who plan for the future.

An individual sample of handwriting reflects the writer's training, character and environment. Collectively, the handwriting of a population of any period is a reflection of educational thinking, but overall it is influenced and ultimately moulded by economic need, social habits and contemporary taste.

The intricate Copperplate of the eighteenth century writing master, Champion, shown opposite, reflects in one sense the skill training and leisure of those who lived and wrote at that time.. The flowery decorativeness also speaks of the convoluted courtesies of the age, the gentleman's extravagant bow, the intricate yet controlled movement of the gavotte, the music of Handel, and the rococo tastes of the time. Like those social conventions, Copperplate hid under its deceptive air of grace and elegance a steely discipline. The writers were locked into a rigid movement. Only the unconventional and strongest characters broke away to develop an efficient personal hand.

Within the short space of the period covered by this present study, the changing educational policies, economic forces and inevitable technological advance radically altered the priorities and form of handwriting. These changes show in the models and examples throughout this book as an inexorable (though not entirely smooth) journey towards speed and efficiency. The downgrading of skill training and the freeing of children's creative talent have done the rest. You might say that at the end of the century we have the handwriting we deserve. That statement can be read several ways. It would be a pity to think that our students do not deserve to be taught strategies that enable them to write fast without pain. It might, however, mean that we are edging towards the flexible, efficient, personal handwriting needed to deal with the rapidly changing situation that is likely to face us in the next century.

abcdefghijklm

nopqrstuvwxyz

Copperplate - in general use up until the end of the century using a pointed quill or steel nib.

abcdefghijklm

nopqrstuvwxyz

Civil Service - used from 1860s increasingly until 1930s and even later in some parts of the country.

abcdefghijklmnopqrstuvwxyz

Italic - introduced by Alfred Fairbank in 1932 and used extensively from 1950.

abcdefghijklm
nopqrstuvwxyz

Marion Richardson - introduced in 1934 and used extensively for over 50 years.

Print script - introduced in 1918 used extensively until end of the century as an initial teaching model.

CHAPTER I

The influences on contemporary handwriting

A historical perspective

THIS BOOK IS primarily concerned with the twentieth century. However, there cannot be a precise starting date when dealing with handwriting copy books or teaching methods. What was being taught in 1900 was a result of the circumstances and publications of half a century earlier. Teachers were influenced by their own parents and teachers. Older books would still be in use or republished in new editions. This point is illustrated by data from a national survey of handwriting undertaken in 1956 by Reginald Piggott (see p101). He recorded that, of those who answered his questionnaire, 43% still wrote a Civil Service hand. For that matter a considerable amount of people still do today. The Civil Service model is a simplified form of Copperplate handwriting. It was introduced into Great Britain in the 1860s and began to be replaced in schools during the 1920s and increasingly so from the 1930s onwards (see the table opposite).

Contemporary handwriting can trace its origins through the history of letters and writing implements from Roman times and beyond. A short explanation is needed to link more recent changes in letterforms with the development of pens over the centuries, as well as the alterations in educational thinking and the changing priorities for handwriting itself. British attitudes have been markedly different from those in other parts of the world. Traditionally, British schools have been allowed to develop their own teaching policies. Whole districts, as well as individual schools, have been free to choose their own models and methods of teaching handwriting, or even to neglect the subject altogether. This situation has resulted in considerable controversy. At the same time it provides a rich field for investigating the effects of different models and methods within the same educational environment.

Some European countries, as well as the USA, and Canada, still cling to their Copperplate-based models of a century ago. Tradition, and maybe a sense of national identity, has so far prevented them from taking advantage of the speed and efficiency of simpler models. Others have diversified only in the last decade or so, contributing various simplified models for future discussion.

A long and sometimes sorry story

The renowned paleographer, Professor Julian Brown, contributed a short history of English handwriting to the *Journal of the Society for Italic Handwriting* in 1972. He subtitled his review of cursive handwriting 'A long and sometimes sorry story'. He began: 'The successive cursive scripts of Western Europe have all been generated out of set scripts by the need to write quickly: pen-lifts have been eliminated, and new letter-forms have evolved more or less automatically. Once in being, the cursives have been promoted from the world of day-to-day affairs and correspondence into the formal worlds of the book and the solemn diploma; and when this has happened, they, no less than the set scripts, have been subjected to stylization, systematization and elaboration'.

Brown continued: 'The elaborated forms of cursive have eventually had to be abandoned, either for practical purposes or aesthetic reasons, and in every case handwriting has been reformed through a return to a version, generally a modified version, of some earlier script which seemed to lack the vices of its descendants. The long slow progress towards the reasonable goal of a fully cursive handwriting in which almost every letter could be made without a pen lift and in which every letter could, if the writer wished, be joined to every other letter, has been interrupted by a combination of two factors: the fatal tendency towards systematization and elaboration, and a hardly less regrettable tendency to over-correct when choosing a model from the past. Hence the sadness'.

Professor Brown's comments are particularly valuable because so many of those versed in the history and practice of letterforms seem to confuse the everyday with the formal. Alfred Fairbank, the calligrapher who contributed so much to the revival of italic handwriting, briefly charted the history of handwriting from earliest Sumerian Cuneiform, via Egypt, and China, into Latin scripts in his *Story of Handwriting*. When describing events in Great Britain he discussed Copperplate and briefly print script. The emphasis of the second part of his book, however, was on the history and practice of the italic hand. He believed this to be the ideal model for all purposes, in education and beyond. Like several authors who followed him in the middle of the century, personal stylistic preferences tended to get in the way of a balanced history of everyday handwriting. They tended to use history selectively to justify their preferred model.

Desmond Flower, who wrote a brief survey of English handwriting in the letterform journal, *Signature*, in 1936, was another influential exponent of italic handwriting. He took a slightly different view of history and began in an informal way: 'It is frequently taken for granted that letterforms, like golf clubs

or easy chairs, have always been much the same, except in some far off age which bears no relation to our own. We are delighted by early manuscripts which gleam in gold and rich colours within the glass cases of every museum, but these marvels are so remote from us that they might have been penned by the man in the moon. Yet an unbroken chain of history links such ancient mysteries to the painful letters which our housemaid grinds out when she signs for a registered parcel.' Flower explained how: 'The form of hand which Western man writes today, springs with few exceptions from the *cancelleresca corsiva*, or chancery cursive which was adopted by Eugenius IV (1431–1447). He interpreted its introduction this way: 'It was a reactionary hand. The Florentine scribes of the Renaissance, impeccable in their taste as were most Italians in that remarkable age, no longer cared for the writing of their forefathers, which had become debased, full of marks and symbols which symbolised nothing. They turned back to the purer Caroline letters of the eleventh century for inspiration'. Flower then gave a detailed account of the beauty of this new writing which evolved into the italic form as we now know it. Flower recounted that this form was fixed when Francesco da Bologna was employed by Aldus to cut a new type which was said to be based on the handwriting of Petrarch.

In 1936 Flower, like many other contemporaries in literary or artistic fields, was dissatisfied with contemporary Copperplate-based handwriting. He continued: 'Today the time has come once again when we should put our house in order and turn back three hundred years as the scribes of Renaissance Italy did'. Not surprisingly, Flower deplored eighteenth-century writing, believing that the last link with Renaissance Italy was broken when looped ascenders were adopted. He finished by explaining how: 'In many walks of life a sense of utilitarianism is lacking where it is most needed, but the problem of handwriting is curiously the reverse. It is simple for anyone to write and it is, indeed, a necessity. Handwriting would be far better if it were not so much part of our life, for now we form letters as we make casual conversation and think nothing of where we are at'.

Some sixty years later we probably need just the kind of writing that Flower so disliked – multi-purpose, personal letters that we can use without concentrating too much on their style. In addition, what may be desirable and admirable in an adult hand, may not always be the most suitable model for the young learner. But history is useful. Those who ignore the history and implications of letterforms are ill-equipped to design models for children today, while those with informed attitudes and open minds can take what is best from the past and harness it for use in the modern world.

13

Issues to balance in handwriting

Handwriting is a complex and emotive issue. It is difficult to be objective about a subject on which many of us hold strong personal views. In presenting a history it is not easy to strike a balance between being critical but fair at the same time. It must be done in such a way that readers are able to judge for themselves the effects of the various models and methods that appear in this book, bearing in mind the other contemporary issues. The way these various factors interact seems to be the key to understanding how this historical survey might be of practical use today.

To start with, the different priorities for the task of writing need to be balanced against each other. Some of the factors have remained constant since the earliest writing systems evolved, but there are others which are more evident today.

- The most important balance is between clarity and speed. In general the faster you write the less legible it will be. There are some occasions when speed is more necessary than absolute clarity, and others when legibility is of utmost importance.

- Secondly comes the balance between the needs of the reader and the needs of the writer. This concerns the respective requirements of the eye for recognition, and the comfort of the hand that writes (especially at speed). It also involves a balance between the writer's need to get enough down on paper and to keep up with a train of thought, with the reader's expectation (often perceived as a right) to be presented with *neat* work.

- The third balance is between beauty and practicality. This can be a balance between the readers' and writers' tastes or demands, or concern only the writers' wish to produce what they perceive as an aesthetic presentation. This is likely to be at some cost to length or content.

- A more recent balance is between the time-consuming skill training and the need to use writing creatively at an early age. This has become an important issue for curriculum planners.

The first reaction to a model may be whether it is pleasing or not to the viewer, but this may not be relevant in educational terms. When judging models it is necessary to consider how well the model relates to the writing implement, the needs of the writer who will use it, and whether it will develop into a suitable script, bearing in mind the educational and social climate of the age in which it was, or will be, used. How easy it might be to teach or acquire needs thought, as well as whether any particular script would be capable of being

developed in such a way as to satisfy those who wish to acquire (or be presented with) aesthetically beautiful writing.

A new model, however attractive, proves nothing by itself. The designer's claims for its supposed success are not enough, nor are the perfect examples of pupils' work that are usually available to promote the benefits of almost any model. Most obedient and diligent children can be taught, at a young age, to reproduce almost any letterforms by a determined teacher. Once automated, and closely adhered to over a period of time, only the strongest (and maybe the creative and rebellious) characters are likely break the mould of a strictly enforced model and find a mature, personal hand which suits their personalities and fits their specific needs. By the time they are free to write as they wish, it may be too late for them to experiment and find the short cuts which lead to a fast personal writing. Therefore, what is claimed as a benefit of keeping to any particular model may in the end be of detriment to the writer.

The proof of a good model lies in whether a large variety of children are able to develop fluent, legible, personal handwriting from learning it. Where the ductus (the movement within and between letters) of the model is faulty, the resulting script may be unable to join easily or speed up. It is unlikely to retain legibility at speed. A model that involves inessential details will produce inefficient, fussy writing. This is likely to deteriorate further at speed.

Wherever possible, poor examples of children's writing as well as good ones must be examined to compare and contrast the effects of different letterforms. It is just as important for a model to work well with low achievers as with high achievers. Examples of mature scripts arising from the various models are equally useful (if not vital) in judging the long-lasting effects of models. Some examples relating to specific models appear throughout this book.

It is difficult to give firm guidelines for good or bad handwriting. It would need a huge range of examples to give other than a selective view of something that depends so much on the tastes and the eye of the perceiver. In 1952 Wilfrid Blunt wrote in his book *Sweet Roman Hand:* 'All good hands, in so far as they adhere reasonably closely to the accepted forms of the Roman and Italic founts, show a certain amount of similarity; all bad hands diverge in their own particular way from the norm, thus acquiring what some people allege to be *character'*. Yet character, along with legibility, efficiency, consistency and an ability to speed up, produces the handwriting we need today. When it comes to bad handwriting other factors intervene. The writer's level of education, maturity or even health, can influence the written trace, while severe tension, from whatever cause, can distort good writing at any age. Neither model nor method should then be blamed for poor handwriting – nor even the writer.

Pens, pen holds and the resulting letterforms

Writing masters of the sixteenth century understood that there was a relationship between the writing implement, the prescribed pen hold and the resulting letterforms. When the pen altered, as has happened frequently in the last few centuries, and drastically in the past few decades, then there might be a need to alter the pen hold. These changes would be likely to affect the letterforms. When a model altered it might require a different pen hold and be best reproduced with a particular writing implement. When judging a model it is important to bear these points in mind. When designing a model it is even more important. Teachers in centuries past were more accustomed to considering such points, building on what they had been taught in their own school days. It is only in more recent years that such matters have been so ignored that copy sheets alone may be insufficient to enable teachers, who themselves were not taught adequate strategies, to teach handwriting. Today many books on handwriting seem to suggest that there is only one correct way of holding the pen or pencil. A review of some classic pen holds illustrates how hand positions and pen hold have consistently altered to match new models and implements.

At the beginning of the century many young children practised their letters on a slate with either a slate 'pencil' or chalk. When a mistake occurred it was easy to erase and alter. A hundred years ago many children graduated from pencil to using pointed steel nibs. This was a nightmare for the unwary Copperplate writer. A sudden blot would spoil a careful piece of work. As the Civil Service models became fashionable, with less pronounced gradations of thick and thin strokes, slightly less pointed steel nibs became available, including the aptly named *relief* nibs. The problems of watery or sticky pots of ink still stood in the way of good writing. The ink monitor had a responsible job in the age of the dip-pen. This was described in Whalley's book, *Writing Implements and Accessories*. Gordon and Mock reminded us in 1960, in their book *Twentieth Century Handwriting*, that, despite all these difficulties, attitudes in education alter slowly: 'When inexpensive fountain pens came into use in the 1920s they were banned in almost every school, and few children were ever taught to write with them. Now ball points suffer the same fate'.

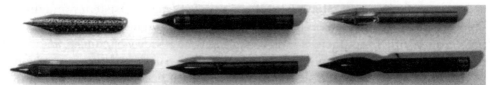

A selection of steel pen nibs from the collection of Philip Poole.

When the pointed quill or metal nib was used for Copperplate-based letterforms the hand was not placed firmly on the writing surface as it is today. The hand rested lightly on the desk, usually supported only by the little finger, in order to exert the changing pressure that produced alternate thick down and thin upstrokes. This light pressure also enabled the whole hand to glide easily along the line and write long words without lifting the pen. To stop in the middle of a word usually resulted in an unsightly ink blot.

The subtle change from a lightly supported hand to the way we write today, with our wrist and hand much more firmly on the table, has happened slowly as pens altered and print script and semi-cursive models came into use. For many years traces of older habits remained. Well into the second half of the century traditionally trained teachers still impressed on their pupils the importance of a light hold on the pen. They would go behind the desks testing to see how easily it could be removed from their pupils' grasp.

Continuous Copperplate-based cursives do not work well with free-flowing modern pens. Firmly supported hand positions (even more necessary in order to control modern pens) mean that the hand does not move so freely along the line. Pen lifts must be allowed during longer words, otherwise this combination of the pen and the way we write will strain the muscles of the hand and eventually distort the letters.

The position at the end of the century is complex. Modern pens of all descriptions, felt and fibre tips with many different sizes and textures of point, vie with ball points and rollerballs. Young children once used coloured or lead pencils. Now many pre-school children use felt-tipped pens when evolving their mark making strategies. These work in a more upright elevation than a pencil. In infant classes, although pencils might be used in actual writing classes, felt-tipped pens are used for other activities. Do children then hold a pencil, which can work at any elevation, in the same way they hold felt tips? Children's hands appear to be becoming less developed and ready to write – this is the price of progress as they have less specific tasks to perform in the home. It makes the task of teaching an effective pen hold difficult, yet children are expected to communicate through writing earlier than ever. All this seems to contribute to unconventional hand positions. Once automated, such pen holds are not easily altered. The question *is the pen held correctly?* is no longer simple to answer. The unconventional pen holds, seen in most schools, may be signalling that we need to consider a new pen hold and/or hand position for new pens. Callewaert, a Belgian neurologist, researched an alternative way of holding a pen during the 1950s (see the illustration on the next page). This may provide us with a solution.

PEN HOLD

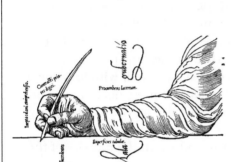

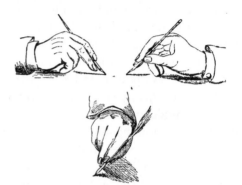

HOW TO HOLD THE PEN.

Place your fingers two and two,
 Let your thumb be bent;
Keep your wrist *up*, and let your arm
 Be near your elbow leant!

Rest hand on little finger's tip,
 See well what you're about;
By having right eye vertical,
 And keep your elbow out!

Pen holds have altered during the last few centuries to deal with different pens and changing models. Above left: In 1540, Gerhard Mercator described the good and bad points of pen hold for use with a broad-edged nib when writing the Italic Chancery hand. Above right: In 1878, William Stokes illustrated and described in rhyme the 'two and two' pen hold for writing Copperplate with a pointed quill or steel nib. Below left: Henry Gordon, at the end of the 19th century, showed a subtly different pen hold. Below right: In 1962, Callewaert, a Belgian neurologist, researched and proposed an alternative pen hold. It was intended to alleviate writer's cramp. It works well with modern pens.

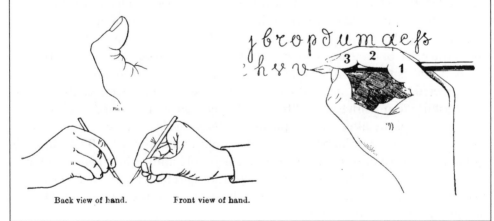

Back view of hand. Front view of hand.

WRITING POSTURE

21
POSITION OF THE BODY.

Left side incline towards the desk,
 Left arm rest near to the desk's edge ;
With left hand hold the paper down,
 Your chest upon the desk don't wedge !

Put your paper square with desk,
 A little to the right ;
Your pen-prongs point in such a way
 That both at once may bite ! W. S.

Above left: William Stokes' rhyme detailed the posture and paper position suitable for Copperplate. Below: his illustration of a late 19th-century classroom showed slanted desks. His caption read: 'Boys writing showing the ordinary position of Body and Hand after training'. Both of these come from 'Stokes' Rapid Writing'. This is an unusual manual. It concentrated on speed rather than perfection. Above right: the directions for writing posture appeared on the cover of Jackson's 'New Style Vertical Writing Copy Books' towards the end of the 19th century.

GENERAL DIRECTIONS

THE WRITER should sit straight before the desk or table, with both arms partially placed thereon. The head should incline downwards only sufficiently to command a clear view of the copy. The right hand must maintain its natural relative position as the arm rests on the desk, no twisting at the wrist or fingers being necessary.

THE BOOK must lie square and evenly on the desk before the writer, the writing portion being opposite the right half of the writer's body, and it should be moved up or down to suit the writing according as the latter is near the foot or top of the page.

THE PEN should be held moderately firmly between the thumb and two forefingers, the former being bent up and away from the ends of the fingers, which must not approach too near the tip or point of the pen. As to direction, the pen should point somewhat outwards and towards the elbow of the right arm. Both points of the nib should be equally employed in the act of writing.

THE WRITING must as far as possible be uniform in size and shape unless where junction may necessarily modify the formation of any special letter. It is intended that all words should be written continuously from the beginning to the end without lifting the pen, unless in the case of capitals and the letter x.

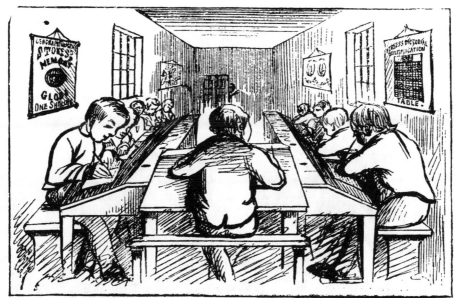

Boys writing at School ; showing ordinary position of Body and Hand after proper training.

Ways of correcting penhold

Nineteenth-century writing masters were prescriptive about the pen hold for Copperplate writing. Joseph Carstairs was influential both in England and the USA. His method of binding the fingers into position was one of the most extreme of those aimed at controlling the movement of the fingers thus ensuring the desired whole-arm involvement in the act of writing. The Writetrue finger guide appeared in Philip and Tacey's catalogue in 1909 (see opposite). The Zaner Bloser writing frame, still advertised in the late 1980s, had remained unchanged for a hundred years. Kinder, triangular pen grips are used today.

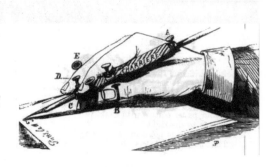

Above: A device to hold the fingers in the prescribed position and to counter the problem of writer's cramp. The drawing comes from 'L'Arsenal de la Chirurgie', 1867. It is reproduced from 'Writing, the Story of Alphabets and Scripts' written by George Jean, by permission of Thames and Hudson. Right: A modern plastic pen grip used to promote a conventional pen hold. Below: Joseph Carstairs' method of binding the fingers.

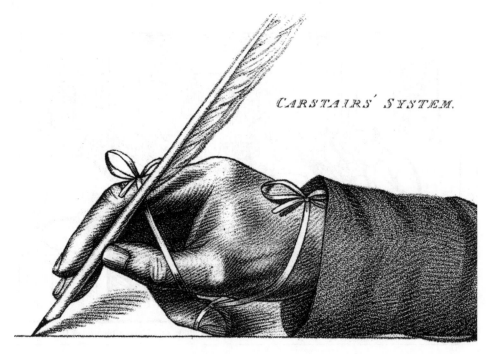

CARSTAIRS' SYSTEM.

EQUIPMENT FOR CORRECTING PEN HOLD

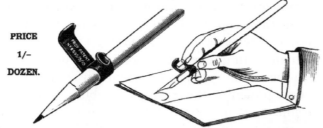

EVERY SCHOOL SHOULD ADOPT THE

"WRITETRUE"

FINGER GUIDE and PEN REST

(Provisionally Protected.)

THE ONLY METHOD OF ASSURING CORRECT WAY TO HOLD THE PENHOLDER.

The use of this patent guide enforces Scholars to hold the pen in the correct fashion, and thus enables them to produce good results.

PRICE

1/–

DOZEN.

APPROVED

AND

RECOMMENDED

BY

INSPECTORS.

First Finger to be placed on arm, and Second Finger on side Rest or Guide.

Enables young Children to learn to write correctly in a very short time.

OTHER USEFUL PREVENTS PEN OR PENCIL FROM ROLLING OFF DESKS.
ADVANTAGES PREVENTS BLOTTING OF BOOKS.

MADE IN TWO SIZES AS FOLLOWS: { No. 1. For Usual Small School Penholders.
 No. 2. For Black Lead Pencil and Medium size Penholders.

A SAMPLE WILL BE SENT FREE ON APPLICATION TO **PHILIP & TACEY, LTD.**

An advertisement from the catalogue of Philip and Tacey, the educational supplier dated, 1909. Below: Instructions on how to use the Zaner Bloser Writing Frame. These are still sold today.

The
ZANER-BLOSER
Writing Frame

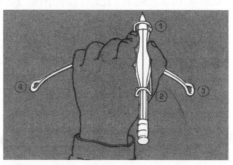

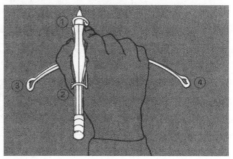

Details of teaching methods

Writing manuals in the last century gave detailed, often didactic, instructions for classroom teaching, as well as providing exercises based on copying their preferred model. By the 1860s, mass-produced copy books became popular. Some consisted simply of a collection of pages to copy, with little or no indications of a method. Some included a prescribed pen hold, some even more detailed postural requirements. Some prescribed different sizes of letters at different stages within the same copy books, and many series of copy books were graded to form progressive exercises (see opposite).

In later years many handwriting schemes incorporated separate teacher's books. There was no guarantee that schools would purchase these manuals, or use them even if they were present in the classroom. Publishers' records disclosed that sales declined after the 1950s. Without a teacher's manual the instruction was often limited to copying the model. Methods were forgotten. The well-known scheme by Marion Richardson, *Writing and Writing Patterns*, first published in 1935, demonstrated what can happen. The copy books were popular well into the 1980s. By then the teacher's book had long been out of print because of declining sales. This meant that the author's concept of a

GRADUATED SCHEME FOR TEACHING WRITING, ARRANGED ACCORDING TO THE AGE OF THE CHILDREN.

STEP.	INFANTS' SCHOOLS AND CLASSES.	AGE.		COURSE.		
1.	,,	Under 4 years.		Scribbling and rough drawings of common objects.		
2.	,,	4—5		*lll, m, mm, m, n, mnmn, lll, i, mi, in, u, c, a, e, v, w, s, r, x.* with their combinations to form short and easy words.	Letters of one space.	Size = ¾-inch, written on ruled slates with pencil.
3.	,,	5—6		*lll, lll, l t, d, h, l, p, lll, g, j, g, y, f, k, z.* Short and easy words and sentences. Figures. } Continuous writing.	Letters of more than one space.	
4.	,,	6—7		Capital letters. Short sentences from dictation. Transcription.		
5.	SCHOOLS FOR OLDER CHILDREN.	STANDARD I.	YEARS. 7— 8	The course prescribed for children of 4-6 years, but written on paper, first with black lead pencil, then with ink.	Size = ⅜-inch.	
6.	,,	II.	8— 9	Capital letters, words, and short sentences.	Ditto.	
7.	,,	III.	9—10	Transition from half-text to small hand, written between double lines, ₁₆-inch apart, with the introduction of loops, etc.	Size = ⅜-inch, and ₁₆-inch.	
8.	,,	IV.	10—11	Small hand.		
9.	,,	V.	11—12	Current hand.	Size = ⅛-inch.	
10.	,,	VI. & VII.	12—14	Current hand and ornamental writing.		

Henry Gordon described his book, 'Handwriting and How to Teach it', as a practical treatise. His graduated scheme detailed what was expected of children at each age at about the turn of the century.

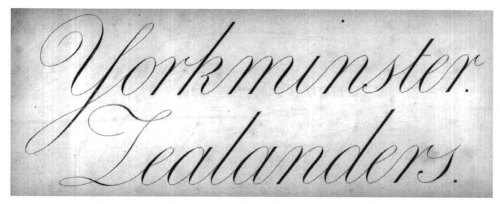

Four sizes of script, from 'Large Text' (above)to 'Running Hand' (below) appear in this 1846 copy book.

simple first alphabet developing into a mature script was lost. Juvenile copy books were being used for all ages, leading eventually to the whole scheme being criticised for producing immature handwriting.

The size of copy books as well as the precise dimensions of the characters in graduated series of written exercises was important. As Ambrose Heal wrote in 1931: 'The older the writer, the smaller the copy book'. The one illustrated here, dated 1846, measured about 18 cm. by 7.5 cm. suggesting that a short exercise, written slowly and carefully, was considered good practice. The flimsier, paper copy books, in use after the 1860s, measured around 21 cm. by 16 cm. The use of photocopiers means that, in the interests of economy and convenience, young children today are often faced with A4 (28.5 cm. by 21 cm.) sized copies. These large pages, often crammed from margin to margin with text and illustration, are often too complex for young children to assimilate. They are neither child-friendly nor conducive to careful work.

ONE MAN'S LIFETIME OF COPPERPLATE

Morning Prayer.

Father of All: we return thee most humble

& hearty thanks for thy protection of us in the night

Daniel in antrum Leonum

conjectus.—

En Rex Arcadidas qui sub ditione tenebat

Crudelis, scrum jecit in antra, Dei.

Hic Leo stat furiosus, terrens alius illic

Book the second—

I. Virtue being divided into intellectual and

moral, the former is produced and increased

chiefly by instruction, and therefore requires

"O dreadful thought, to rise again,

With bodies that can never die;

But which for ever must remain,

In endless bliss or misery!

BGG's writing as a schoolboy, a student, aged about thirty and aged about eighty.

PROFESSIONAL SCRIPTS

By my Will bearing even date herewith I have
constituted you my Residuary Legatees, and it is
my wish which I feel assured you will carry out,
that as soon as conveniently may be after my decease

Bill No 13.

Chimney Shaft & Flues.

All Trades.

The following work is
principally comprised in
the erection of a chimney
shaft of a total height
of 140'.0" from the top of

fourth part and *Sir John Kirk* of No. 12 Sir
Gardens Campden Hill in the County of Middlesex
Her Majesty's Consul General at Zanzibar of the
Whereas by an Indenture dated the Nineteenth

Top: An 1850s codicil. Centre: A 1903 builder's estimate and a parchment indenture dated 1885.

25

The Cat.
Here is a nice old cat
She has a kit in her
mouth She will not
hurt it. Oh no, but
she will take it to
a safe place and
hide it. If puss were
to see a mouse she
would catch it and
eat it very quickly

A Copperplate exemplar from Henry Gordon's undated book,
'Handwriting and How to Teach it'.

CHAPTER 2
The turn of the century

Two BOOKS, in use at the beginning of the century, illustrate the dual influences on handwriting in Great Britain during the early years of the twentieth century: those of the educationist and the calligrapher. These two books need to be described separately and their aims and principles compared. The first is called *Handwriting and How to Teach it.* According to the original owner, it was used by her father who started school at precisely the turn of the century. It was undated, as are many manuals and copy books. This is probably because publishers had no wish for their products to be perceived to be out of date. The only clue to its date is a reference to a letter from Lord Palmerston dated 1854. This modest book, price one shilling, seems to have been published some years after this date, probably about 1875. It would have been in use in schools for quite a few years by 1900. It was written by Henry Gordon and published by John Marshall and Co. of Paternoster Row.

The second book is better known. Entitled *A New Handwriting for Teachers*, it was written in 1899 by Mrs Bridges, wife of the poet Robert Bridges.

Henry Gordon's *Handwriting and How to Teach it*
This book provides us with a detailed picture of how handwriting would have been taught in many elementary schools. It dealt with all aspects of the task including a graph showing a graduated scheme for teaching handwriting arranged according to the age of children (see page 22). So, for instance, Gordon suggested that under the age of four years, children should be encouraged to scribble and produce rough drawings of common objects. Then between four and five years they should be introduced to what he termed 'letters of one space' (letters without ascenders or descenders) singly and in combinations to form short and easy words. The scheme gives us a glimpse of the expectations for elementary school children at the end of the nineteenth century showing, for instance, how a considerable amount of practice was provided on a slate before expecting a child to copy joined words or sentences. This method would provide a systematic progression from childish scribbles to 'the highest class in the school, in which class copy-writing might be almost, if not altogether, superseded by the practice of the business hand'.

This small, 96 page book fills in many details, important to the history of education, that cannot be learned from many of the copy books of the day

HENRY GORDON'S COPPERPLATE MODELS

Unlooped and looped alphabets from Henry Gordon's Handwriting and How to Teach it.

which were mostly confined to exercises for practising the various models.

Looped and unlooped forms of separate and joined Copperplate letters, capital letters, details of height differentials and specific joins were all shown. Precise prescriptions for pen hold were given (see page 18), also issues such as line spacing,and the differences between Large Hand and Half Text. The details of such matters as supervision in class illustrated what an excellent teacher Gordon must have been, exemplified by this remark: 'Many teachers tell the class to go on writing and then proceed to some other class or duty and leave the children to themselves. However necessary it may be that the teacher's attention should be otherwise directed, it is obvious that the writing class must suffer from the lack of constant supervision. Without guidance the errors made will be copied and re-copied until they become habitual'. This advice is just as important today, when teachers may feel that it is enough to distribute photocopied sheets to the class and get on with another task, as it was at the turn of the century – yet such warnings are seldom to be seen in modern handwriting schemes. Gordon was also against a whole class writing one exercise in a certain fixed time because, as he said: 'Under such a system much of the time of forward scholars will be wasted, and the careless ones who hurry will not be made more painstaking'.

Gordon's admonitions concerning corrections were sensitive but practical at a time when a more dictatorial atmosphere prevailed in the classroom: 'Errors should be slightly marked if necessary, in pencil, but not so as to deface the book. If sundry untidy marks are made by the teacher, the scholars cannot be expected to take a pride in keeping their books neat and clean. Too many corrections will tend to confuse a scholar. It would be better to notice the most prominent ones first. The teacher should make sure that the child knows exactly what mistake it has made; and for this purpose it will be necessary to speak distinctly and plainly, but not in a fault-finding tone'.

'Far too little attention is paid to the child's body when engaged in writing', wrote Gordon. 'The teacher should be constantly and regularly going round the class, detecting and correcting the errors which occur, either in the management of the hand or pen, the position of the book, or in the writing itself'. His advice 'never use handwriting as a punishment' must have been revolutionary at the time, and for years to come, when 'lines' were used as punishment for the slightest misdemeanor.

With all his obvious knowledge and experience, Gordon's modesty showed in his preface where he wrote: 'The suggestions made in this essay may not commend themselves to all, but if the reader should be led to think sufficiently on the subject to form his own plans, the object of the Writer will be attained'.

MRS BRIDGES' INITIAL MODEL ALPHABET

STROKES	LETTERS	STROKES	LETTERS
l l	i t u	o	o
ı	r	c	c e
ı	n m	o	a d
l	h p f	b b	q j g
l	l b	k	s x
v	v w	y	z z

1 2 3 4 5 6 7
8 9 0

*T*HE *Accompanying plates are inten-
ded chiefly for those who teach Wri-
ting: a few words, both of apology & ex-
planation, are needed to introduce them.*

Mrs Bridges and *A New Handwriting for Teachers*

Mrs Bridges' attitudes were influenced by the Arts and Craft Movement of the end of the 19th century and the work of William Morris in the revival of what she termed 'the Italianised Gothic' of the sixteenth century. In her book entitled *A New Handwriting for Teachers*, published by Oxford University Press in 1899, she described how: 'I consciously altered my hand towards some likeness with its forms and general character. This script happening to please, I was often asked to make alphabets and copies, and was begged by professional teachers to have such a book printed, that they might use it in their schools'.

Her copy sheets are accompanied by a text showing Mrs Bridges' concern

Left: Formal calligraphy from the Yattenden Psaltery, lettered by Mrs Bridges, resemble the early model she proposed for children. Right: Mrs Bridges' informal handwriting. All the examples of Mrs Bridges' work are reproduced by permission of Oxford University Press.

with aesthetics, that is itself an example of typographic excellence (see above). She disliked the old copybooks, exclaiming: 'The average hands which are the natural outcome of the old copybook writing, degraded by haste, seem to owe their common ugliness to the mean type from which they sprang'.

Turning her calligraphic skills to the teaching of handwriting she continued: 'For young beginners I give simplified forms and the order in which it is convenient to learn them. A child must first learn to control his hand and constrain it to obey his eye: at this earliest stage any simple form will serve the purpose; and hence it might be further argued that the forms are always indifferent and that full mastery of the hand can as well be attained by copying bad models as good; but this can hardly be: the ordinary copybook,

31

a b c d d e ɛ ꝼ f

g h i j j k k l m n

o p p ꝗ q r s s t f u

ʋ v w w x y z z

ff ſ. gg th st æ œ &

Second alphabet, double letters and short words from Mrs Bridges' 'A New Handwriting for Teachers'.

and. he. be. of. joy.
vow. oxen. so. is.

All the ways of life are pleasant; in the market place are goodly companionships & at home griefs are hidden; the country brings pleasure, seafaring wealth, & foreign lands knowledge.

In Mrs Bridges' own words: 'These plates show what the script is like when it approaches a current hand'.

Thyrsis, the reveller, the keeper of the nymphs sheep, Thyrsis who pipes on the reed like Pan, having drunk at noon, sleeps under the shady pine, & Love himself has taken the crook & watches the flocks

the aim of which seems to be to economise the component parts of letters, cannot train the hand as more varied shapes will; nor does this uniformity, exclusive of beauty, offer as good a training to the eye'. She added that: 'It is certainly desirable that there should be more good models for slow writing as there is abundant occasion for its use'.

Many letters in Mrs Bridges' model for beginners involved pen lifts between the strokes. They resembled those in her own formal lettering as shown in the Yattenden Psaltery (see page 31). She admitted with disarming modesty: 'Whether such a hand as that here shown lends itself as easily as the more uniform model to the development of a quick, useful cursive, I cannot say'.

Mrs Bridges' 'Instructions for how children should use these copies' were not very detailed. She wrote that it is important that pen, inks and paper should consort well and wisely and she notes that a pen that suits one paper writes ill on another. She suggested the use of ordinary 'sermon paper which is used with faint lines about 5/16ths of an inch apart, making the short letters the height of a space'. She recommended a fairly yielding broad-edged nib or quill. About pen hold she wrote: 'Enough has been written and said about the position of the hand in writing: I would only recall the old traditional rule of two fingers on the pen, which seems to have been founded on experience and not without reason'. However, the tradition of two fingers on the pen relates to Copperplate handwriting using a pointed quill or nib rather than the broad-edged nib she proposed. Although the capital letters are displayed first, Mrs Bridges noted that 'of course' children should start with small letters. She continued: 'When the simple forms are mastered they can go on to the more varied and difficult forms'. She included numerals at an early stage – something that was often ignored in later copy books. Mrs Bridges also illustrated double letters saying that: 'The double letters are only suggestions, but such small varieties add interest to the appearance of manuscript'.

It has been difficult to verify examples of handwriting by pupils who might have been taught from Mrs Bridges' copy sheets. It is likely that they were used by governesses, small private schools which were springing up to replace the dame schools of the previous century, or elite boarding schools for the rising generation, of girls in particular. Mrs Bridges, and her husband, the poet Robert Bridges, were involved in many issues concerning handwriting, spelling and legibility in the early part of the century. His tracts, numbers XXVII and XXVIII on handwriting, printed by OUP during the 1920s, review the state of handwriting not only in Great Britain, but also around the world.

Mrs Bridges completed her husband's last tract, which was concerned with orthographic reform, for the Society for Pure English after his death in 1935.

Comparisons

These two books were probably directed at different levels of the system of education. At the turn of the century, Gordon's book, aimed at teachers in elementary schools, was clear about its purpose and priorities, taking note of the expectations and likely careers of the pupils who might be learning his method. The elementary schools were a training ground for the clerks who recorded the business in office ledgers before the general introduction of typewriters. Their livelihood depended on a good, clear hand. As Gordon wrote: 'To persons in the lower and middle ranks of life a good and rapid style is of special importance as legible writing quickly executed is in constant requisition in all trades and businesses'. He alluded to the importance given to the subject of handwriting saying: 'Parents and others are disposed to take the quality of the writing as an index of its general character; and the test is by no means an unfair one. The old race of teachers owed their success in keeping their schools together and in making a reputation for themselves very much to the fact that they taught handwriting well. Whatever other subject was neglected, this had its full share of attention'.

Mrs Bridges' book signalled a change – from those written largely by experienced teachers, who were probably competent in penmanship themselves, to those of writers who used their own handwriting, derived from whatever historical source, as a model – people for whom the aesthetics of handwriting were sometimes more of a priority than educational issues. As Professor Julian Brown wrote in 1972: 'The movement inspired by William Morris for a better sort of everyday handwriting has had its reactionary side. The search for models in the past has mostly taken it back beyond England in the eighteenth century to Italy in the Sixteenth... and style rather than practicality has been the main object of its concern'.

Script of a pupil of Mrs Bridges' 'New Handwriting', from Fry and Lowe's 'English Handwriting', 1926.

Mrs Bridges' book was an indicator of changing attitudes. Her classical model, aimed at children, was an important step in the development of the italic handwriting movement. It is books such as that of Gordon, however, which must have been of most assistance to teachers and had most influence over the handwriting of the majority of pupils at the turn of the century.

The cover of the 1898 catalogue of the old established firm of Philip and Tacey.

CHAPTER 3

Learning from copy books

THE CENTURY OF THE penny or twopenny copy books ranged approximately from the 1860s to the 1960s. Their use peaked about the beginning of the twentieth century and began to decline after 1920. The term copy book seems to have been used in several different ways. An actual book such as Gordon's might have been termed a copy book by teachers who would have used the models in them to copy on to the school blackboard. In the ninteenth and early twentieth century many children would have copied from the teacher's representation of the model onto their individual slates. To help teachers, and reinforce their teaching, there were 'writing sheets mounted on large stout mill boards', according to the 1898 catalogue of the old established firm of Philip and Tacey. There were copy books where the top line, the exemplar, was printed, and the rest left blank, and there were blank or lined copy books (the same word) for children to practise their letters. Sometimes a teacher or governess filled in the top line with their own model, in others the child started straight away.

Series of copy books also included exercises for spelling, grammar, mathematics, drawing etc. Although cheap by modern standards, they represented quite an extravagant outlay to a village school, so home-made exercise books were often substituted. The wide range of each series of copy books, revealed in publishers' archives, indicates the care taken in designing progressive courses for pupils. Graduated exercises were used to practise details of strokes, individual letters and joins. They show various ways of indicating lines or divisions between words, as well as practical instructions.

The familiar claims for the virtues of different models indicate that the subject was no less controversial a century ago than it is today, while plenty of examples demonstrate that learning to write was just as difficult for children then as it is in the 1990s. Some of the problems that children experienced are illustrated by examples of used copy books on pages 52 and 53.

The term copy book gradually took on a different meaning. Work book, copy sheet, writing cards, then handwriting scheme took over – different words but the same purpose – to teach and provide practice in handwriting. A copy book now might as easily be a photocopiable book of exercises for spelling or comprehension as one for handwriting, while alphabets once engraved in a copy book may now be stored on a disc.

Series of copy books

Complete series of these copy books proved difficult to trace. Museums, which would usually conserve such material, have few of these humble ephemeral publications. Luckily, lists printed on the covers of individual copies and publishers' archives give us an idea of what was available. Philip and Tacey, educational suppliers since 1828, provided a comprehensive list of current series in their 1898 catalogue. Macmillan's catalogue of 1897 detailed their own series, and their archivist gave vital information about the length of time that they were available. Three entries related to handwriting: Macmillan's Official Copy books (first available early 1890s), Macmillan's Official writing charts, new in 1897 (on cloth rollers and varnished), and a series of fifteen other copybooks, first available in 1878. The 1878 copybooks were available until 1910, the wall charts went out of print in 1928, but the Official Copy Books outlived them. The last of them disappeared from the Macmillan catalogue by 1943, after fifty years (but not necesarily from shops or schools).

The Vere Foster series proved the most popular and long lasting of all. They could be found tucked away at the back of stationers' cupboards as late as the 1960s. It is still possible to trace people who can remember being taught from them (see page 47). The influence on education of such publications can only be guessed at from such statements as this which appeared on the back of an early undated Vere Foster copy book: 'Writing and drawing copybooks have been adopted by the Commissioners of National Education in Ireland whose purchases already exceed the rate of one million and a half per annum'.

THE NEW NATIONAL COPY BOOKS.

Every effort has been made to render the " New National Copy Books," in respect alike of paper, engraving, and careful graduation, as nearly as possible perfect.

In 14 numbers per doz. 2 0 1 6

1. Medium Text Hand, Strokes, Curves and Easy Words.
2. Medium Text Hand, Easy Words and Letters.
3. Medium Text Hand, Easy Words and Letters.
4. Medium Text Hand, Arithmetic and Words.
5. Medium Text Hand, Capitals and Words.
6. Large Hand and Medium Text, Arithmetic and Words.
7. Large Hand and Medium Text, and Double Small Hand.
8. Large and Small Hands, Geography and History.
9. Large Medium and Small Hands, Grammar and Geography. Standard IV.
10. Medium and Small Hand.
11. Medium Text and Small Hand.
12. Small Hand.
13. Small Hand.
14. Small Hand, Commercial.

JOHN C. TACEY, School Stationer, 17, CITY ROAD, E.C.

COPY BOOKS.—*Continued.*

	Pub. s. d.	Nett. s. d.
Commercial Series Vertical Copy Books, Nos. 1 to 12, per doz.	2 0	1 6
Collins's Round Hand Writers, Nos. 1 to 15 .. „	2 0	1 6
Gill's Neptune Copy Books, Nos. 1 to 14 „	2 0	1 6
Jackson's New Code Vertical Copy Books, Nos. 1 to 22 „	2 0	1 6
Public School Copy Books, Nos. 1 to 15 „	2 0	1 6
The Empire Copy Books, Nos. 1 to 12 „	2 0	1 6
Cassell's Modern School Copy Books, Nos. 1 to 12 „	2 0	1 6
Eclectic Copy Books, Nos. 1 to 12 „	2 0	1 6
V. Foster's Palmerston Copy Books, Nos. 1 to 11 „	3 0	2 3
Darnell's Copy Books, Foolscap, Nos. 1 to 24 ... „	3 0	2 0
Darnell's Copy Books, Post, Nos. 1 to 16 „	6 0	4 0
Chambers's Copy Books, Post size, Nos. 1 to 15 ... „	6 0	4 6
Holborn Copy Books, Post size, Nos. 1 to 11 ... „	4 0	3 0
Boys' and Girls' Own Copy Books, Nos. 1 to 14 „	1 0	9

Any Copy Books can be covered marble, to order, at a cost of 6d. per doz. extra.

WRITING SHEETS.

	Pub. s. d.	Nett. s. d.
The New National Writing Sheets.		
A complete set of 6 Elementary Sheets of new and graduated writing lessons, mounted on 3 stout millboards, size 33-in. by 23½-in. per set	4 0	3 0
Graduated Writing Sheets, in 15 sheets each	2	1½
Or mounted on 8 boards per set	9 2	7 3

JOHN C. TACEY, School Stationer, 17, CITY ROAD, E.C.

Some of the details from the three pages of Philip and Tacey's 1898 catalogue that listed the copy books that they stocked at that time. This valuable source indicates the wide variety of these publications.

Vere Foster

Vere Foster, 1819–1900, who produced the well-known series of copy books in the 1860s, was not himself a writing master. He was described by his biographer, Mary McNeill, as an Irish benefactor. He had assisted many destitute families to emigrate to America and was then touched by their plight because they were often unable to correspond adequately with their relatives back in Ireland. He took it upon himself to remedy this situation and devoted himself to the provision of adequate aids for the teaching of penmanship.

Vere Foster researched the subject thoroughly, enlisting the help of teachers and writing masters. He recalled the views of Lord Palmerston, a family friend. On the subject of handwriting, the then Foreign Secretary had once written: 'Children should be taught to write a large hand and to form each letter well, instead of using fine upstrokes and firm downstrokes that looked like an area railing, a little lying on one side'. This is indeed a vivid description of traditional Copperplate, and Vere Foster took this criticism seriously. He sent selected samples of handwriting and they were returned with a letter from the Prime Minister's wife saying: 'Lord Palmerston is an Enemy to the upstrokes being two (sic) thin and contrasting too much with the downstrokes. He has therefore scratched over with his Pen two of your lines to shew that all the letters should be rounded and clear – and the Upstrokes sufficiently dark not to deceive the Eye, otherwise the letters seem only half formed'.

Vere Foster visited the Prime Minister shortly before his death, and received permission to name the first editions of his copy books 'The Palmerston Series'. As McNeill wrote: 'When before had a British Prime Minister been called upon to assist in the production of copy lines for Irish school children? In his passion for perfection Vere could not have done more'. The books were first published in 1865, having been submitted to eminent educationists, and had their content approved. They were an immediate success and spread to England and America, then throughout the English-speaking world. Their title was soon changed to *Vere Foster's National School Copybooks*, and finally to *Vere Foster's Copy Books*. The letterforms were described on an early cover as: 'In imitation of real free writing rather than stiff Copperplate engraving'. The term 'Civil Service' was added by the end of the century. This might have been because written tests for copy boys and clerks had been introduced into that service in1870.

According to McNeill, Vere Foster ploughed back the profits from his copy books into prizes for national competitions in writing, lettering, drawing and painting. Many other copybooks were published, but in his own words: 'There was never any real competition, Vere's copybooks supplanted all others'.

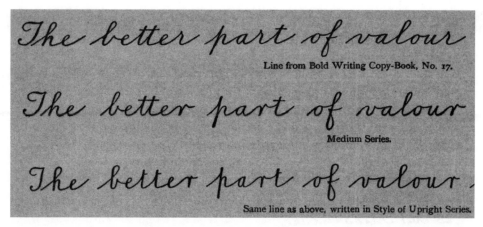

Line from Bold Writing Copy-Book, No. 17.

Medium Series.

Same line as above, written in Style of Upright Series.

Above: According to the inner covers: 'Vere Foster's Copy-books are issued in three styles of writing.
(1) Bold Writing, a legible cursive business hand embodying the principles essential to fluent writing.
(2) Medium Writing, in which the body strokes are lighter and the slope rather less than in the bold series.
(3) Upright writing in which the slope is less than in either of the other series while still sufficient to keep the writing from settling into backhand'.

Below: An exercise from 'Vere Foster's New Civil Service Copy Books Medium Series' and some illustrations from his 'National School Drawing Copybooks, Elementary Series'. Notice that the words Copy Book and Copy-book seemed to be used randomly.

A PAGE FROM A LATER VERE FOSTER COPY BOOK

40 Thornley Terrace,
Belfast,
10th October, 1922.

Dear Miss Rose,

I am very sorry I am unable to accept your kind invitation for Saturday, as Father is going to take us to the Circus on that evening.

With much love,

I remain,

Your affectionate friend,
Mary Carden.

Miss Annie Rose.

A page from 'Vere Foster's New Civil Service Copy-books Medium Series'. Some of the content of this copy book indicates that it must date from after 1922, long after his death in 1900.

COPPERPLATE HANDS ILLUSTRATED BY J JACKSON IN 1898

Kerney Kenyon

Write injuries in dust, but

Those friends thou hast

Tower of London built by

London is the greatest

I go go go on

Naples, the largest city

Malicious men are

The weight of a body is

The Earl of Warwick fell at

Windows were made to

Examples of Copperplate hands from the 'Theory and Practice of Handwriting' by J Jackson 1898.

Details from other copy books

Many other titles appeared during the last quarter of the century. Extravagant claims were made for the various styles. *Cremer's Unit-System of Headline Copybooks* was introduced to 'Improve the handwriting of primary and secondary schools which has so sadly deteriorated owing to a system of penmanship that led to a back-hand style, and because of the unrestricted use of the blackboard as the sole means of instruction (now universally condemned by educational authorities'. *Philip's Semi Upright System of Writing* quoted an Inspector of Schools: 'Who justly remarked that we are in the midst of a contest of styles ... and habits which to an old writing master would have seemed slouching careless and unsatisfactory to the last degree, are tolerated and even encouraged'. The Philip's cover reveals that: 'A careful study of the hand, together with a prolonged series of actual experiments, have proved indisputably that an angle of $15°$ from the vertical is the natural slope for bold clear and rapid writing. This angle of $15°$ is also the mean between the $0°$ of upright writing and the average $30°$ vertical of sloped writing'.

Jackson, in his *New Style Vertical Handwriting Copy Books* made perhaps the most detailed claims and provided some interesting information. He claimed:

'It is the only complete *system* of handwriting in existence comprising of:
 1 Two series of headline copybooks oval and round styles
 2 A full set of wall charts for class instruction .
 3 A manual on the theory and practice of handwriting for teachers
 4 A popular compendium for daily use
 5 A scheme of annual competitions
 6 A complete assortment of writing pens.'

Jackson's *Compendium*, and his *Theory and Practice of Handwriting*, published in 1898, provided: 'Full instructions regarding the teaching of handwriting'. Unlike most of his competitors, he was marketing what today would be called a complete handwriting scheme. He described it as the original system of upright penmanship, scientific and hygienic, simple, easiest to teach etc. and stated that his books were entirely free of all fanciful peculiarities. Other details revealed the extent of Jackson's knowledge. He claimed that: 'It is adaptable to both hands'. An upright model certainly suits left handers better than a sloped one, but his statement was unusual at a time when left-handedness would have been frowned on. An interest ing point is that he also claimed that: 'It entirely prevents Writers Cramp'. His method of joining to rounded letters, (through the letter rather than over the top and back), a habit usually criticised by teachers, would undoubtedly reduce the strain on the hand.

The cover and an example from one of J Jackson's 'New Style Vertical Handwriting Copy Books'.

Look carefully at the enlarged example. Jackson suggested that joins to round letters should go through the centre of the letter rather than over the top and back. This would be less of a strain on the wrist and may well account for his claim that his model would: 'Entirely prevent writer's cramp'.

45

CHILDRENS' COPY BOOK HANDWRITING

5. 11. age 9 Anne Burgess Luccombe School.

A Reason for going to School
One reason why you should be glad to
go to school, and learn all you can while
you are there, is, because the more you learn
the more you will enjoy all the great books
that have been written, the better you will
understand the wonderful works of Nature
and the better use you will be able to
make of its treasures.

FIRST PRIZE.

The prize winning example of Civil
Service hand was written by a nine year
old in a small village school in Somerset
in 1903. The story of the writer reflects
the problems of the day. She was
awarded a scholarship to the local
grammar school but was unable to take
it up owing to family circumstances.

Below is a contemporary page from the
Guide copy book series. It shows how
closely the writer adhered to the Civil
Service model.

Book 4.

THE "GUIDE" COPY BOOKS

NAME CLASS.

DAVIS & HOUGHTON Ltd.

G Gra Granite | *Sc Scot* | *Scotland*

KS, now in her 90s, can remember using the Vere Foster copy books. Her script, in 1912, probably reflects the influence of her governess whose writing also appears here. She can also remember admiring the handwriting of both her parents and trying to decide which one to emulate, (see also page 54).

Standing in front of the
first hive he came to.
he placed a cap on the pistol
and put the muzzle in-
to the entrance of the hive
9/10. Writing rather untidy & careless.

Other sources

Both before and after the turn of the century many children, from all levels of society, were educated at home. Others entered school later when they could already read and write. Many different publications flourished to educate and interest children. Weekly and monthly periodicals with titles such as *Children's Friend* or *Children's Prize* were obtainable for a few pence an issue. They were also available bound into annuals and became prized family possessions, probably used for several generations. One, *Aunt Judy's Paper*, ran a course in penmanship over a period of months in the 1880s. This could be used, unaltered, for children's calligraphy lessons today. These journals provide a fascinating picture of the educational and leisure activities of a century or more ago. Lessons in how to design a secret code, or a 'hieroglyphical' letter would enlarge the concept of communication and could well be used to encourage reluctant learners or bored youngsters.

Along with nearly all the publishers of the copy books illustrated on previous pages, some journals ran handwriting competitions. Several of the publications ran correspondence columns for their young readers. Although, sadly, these letters were not reproduced in the correspondents' own handwriting, they reveal even more of the school and everyday activities of their time. Memory games and specific activities developed the essential skills at an early age. Diary keeping was encouraged and valued, and autograph books with favourite poems and sayings were written out for friends and relatives, encouraging young children to use their handwriting.

An elderly acquaintance can still recall how she had learned to write before starting school, at the age of four and a half, during the First World War. Her mother had used Arthur Mee's *Children's Encyclopaedia* which was first published in 1909. She could remember the satisfaction that she had from copying pairs of joined-up letters, and the thrill of graduating from writing on tramlines to just a base line. These vivid memories remind us of the different expectations and even capabilities of young children nearly a century ago – as well as leading to important material that otherwise might have been missed.

A battered set of eight volumes of Mee's publication, inscribed with the names of children who had enjoyed them in the 1960s, revealed ten superb, progressive lessons in handwriting. Graded from patterns of slanting lines to a fully joined hand, they showed the work of two fictional children. Comparisons and corrections of the two pupils' exercises were an ingenious way of encouraging the users to observe, assess and improve their own efforts. The short handwriting course in a later edition pinpointed changes in attitudes and models that took place during a short but vital period (see page 86).

Children had access to various material at home. Monthly papers such as 'The Children's Prize' and 'The Children's Friend' ran competitions and features to promote literacy. Notice the slanting desks. A cipher from the Children's Encyclopaedia in 1909 would have helped to reinforce alphabetical order.

Extraordinary as this seems, it is really very simple when you have the key to the cipher in which the letter is written. The alphabet is divided up so that it is possible to indicate the position of any one letter by a dot, as is seen here:

a	b	c	d	e	f	g	h	i
j	k	l	m	n	o	p	q	r
s	t	u	v	w	x	y	z	

49

THE CHILDREN'S ENCYCLOPAEDIA

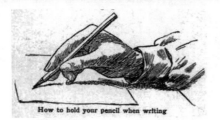

How to hold your pencil when writing

A few of the useful details from the progressive handwriting lessons to be found in the 1909 edition of 'The Children's Encyclopaedia'. See page 86 for details from a later edition.

"Hold your chalk more lightly, Tom; and sit up straight, Nora. Now start, and don't write too fast, or you will write badly."

Tom and Nora wrote over their mother's strokes with their blue chalk, and then tried hard to make strokes themselves.

Tom's strokes

Nora's strokes

When they had finished, Nora's strokes looked nicer than Tom's.

"That is because she ended them on the lines," said their mother.

WRITING

LEARNING TO WRITE LITTLE WORDS

"Here are some small words. You know all the letters, but watch how I am going to join them."

in am
me on
us ox we

Tom and Nora wrote a line each of the words in, am, me, on, us, ox, we, and found all these words easy to write, one letter joining on nicely to the next.

Their mother wrote a number of little words for them to look at and to copy.

ma ha
la no go
to to do

These little words, ma, ha, la, no, go, lo, to, do, had to be written again and again before Tom and Nora joined the first letter neatly on to a and o.

PRINTING FOR MAP DRAWING AND PLANS

Vere Foster's simplified letters found in his undated copy book entitled 'Plain Lettering for Map Drawing and Plans' provide a precedent for the simplified print script letters that were introduced early in the 20th century.

Although better known for his handwriting copy books, Vere Foster's series included architectural and mechanical drawing, watercolour painting etc. His 'Plain and Ornamental Lettering' survived into the era of decimal currency, the 1970s, eventually priced at 60p.

CAPITAL & SMALL LETTERS

a b c d e f g h i j k l m n o p q r s t u v w x y z

A a B b C c D d E e F f G g H h I i J j K k L l M m

N n O o P p Q q R r S s T t U u V v W w X x Y y Z z

1 2 3 4 5 6 7 8 9 0 1 2 3 4 5 6 7 8 9 0

COPY BOOKS – REPETITION, PROBLEMS AND USAGE

After the second attempt the letters usually deteriorate, something that still happens. Above: From a Philips' 'Semi-upright Copy Book' dated 1908. Below: From an undated 'Times Copy Book'.

Numerals were a good test of penmanship. An example from an undated 'Times Copy Book'.

Quarantine Quenchless
Quarantine Quenchless
Quarantine Quenchless
Quarantine Quenchless

Vain, very vain, my weary search to find
That bliss which only centres in the mind,
Why have I strayed from pleasure and repose,
To seek a good each government bestows ?

Vain, very vain, my weary search to find
That bliss which only centres in the mind,

The top example shows how difficult it was to follow the details of the engraved copy sheet. Tension is evident in the decreasing size of the other writer's hand. Both from undated 'Times Copy Books'.

on the "Dark Continent" were the Portuguese
on the "Dark Continent" were the Portuguese
Kenneth Suiter 13 June 1944

had penetrated to Angola and the Zambesi
had penetrated to Angola and the Zambesi
Willie Burnside 27th June, 1944

Two boys still writing, in 1944, in Browne and Nolan's 'Right-line Copy-books (Cremer System)'. The content of these editions suggest that they were printed after 1911.

53

BEYOND COPY BOOKS – PERSONAL WRITING

Perfect examples of copy books and exercises give the impression that learning to write was easy. That was never so, as the above letter shows. Years of careful practice were needed. Below: The writing by KS shows a development several years later than her sample on page 47, and her writing at about 60 and again at 90 show how a disciplined training lasts a lifetime.

HOW CIVIL SERVICE HANDS DEVELOPED

Civil Service models led more easily to personal variations. Those who left school at 13 or 14 to go to work, like the two nannies above, usually kept close to the model throughout their lives. Centre: A doctor's prescription in 1920 shows that their writing could be as illegible then as it is reputed to be today. Below: Exerpts from a 1923 visitor's book illustrate how those who lived at smart London addresses had developed their personal hands. The final script shows the influence of a Copperplate model rather than a Civil Service one, to illustrate the difference.

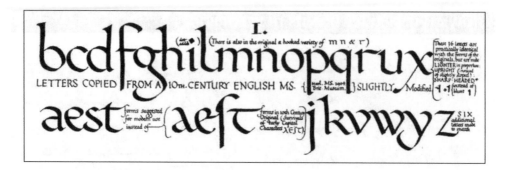

Edward Johnston's letterforms.
Above: Letters copied from a tenth century manuscript from 'Manuscript and Inscriptional Lettering', 16 plates produced by Edward Johnston in 1909 as a working supplement to his book 'Writing Illuminating and Lettering'.

Left: Skeletal forms of letters. Below: An example of his Foundational Hand from Edward Johnston's 'Writing Illuminating and Lettering', first printed by John Hogg in 1906. Johnston's handwriting from a letter written to Alfred Fairbank in 1941. From a 'Book of Scripts', written by Alfred Fairbank, published by Penguin in 1949.

CHAPTER 4
Simplifying letterforms

T HE SIMPLIFICATION OF THE MODELS used for young children soon became an important issue. There was no national handwriting model. The Final Report of the School Board for London 1870–1904 revealed: 'The board have never imposed any uniform system of writing upon their schools'. The curriculum in Great Britain had developed partly by official regulation, partly as a result of advice from the inspectorate, within a system that traditionally gave some freedom to the heads of schools. Local education authorities sometimes ruled on some aspects of certain subjects, but usually after prior consultation with their teachers. One of the consequences has been the proliferation of different handwriting models. Freedom of choice still exists, to a certain extent, in the 1990s within the National Curriculum. It sets goals for handwriting but prescribes neither method nor model.

Edward Johnston and Graily Hewitt, both letterers, sought alternatives for the complex models then in use for young children. Hewitt designed a set of copy books for Oxford University Press in 1916 but Johnston never produced material specifically for children. To Alfred Fairbank (see page 73) he wrote: 'You know something of my idea of non-interference with people's hands but of course when it comes to their being taught either badly or well, I prefer the latter'. His book *Writing, Illuminating and Lettering*, first printed in 1906, became a classic text, influencing handwriting throughout the world.

Edward Johnston – a letterer's contribution to handwriting
Priscilla Johnston wrote a biography of her father in 1959. She described how her father was consulted on the subject of everyday handwriting from time to time. In 1906 he was asked to report to the London County Council on the teaching of handwriting in schools. In this report, according to his daughter: 'He stated frankly that he could not approve of any of the seven nibs and twenty seven copybooks submitted to him'. He advocated the use of broad-nibbed pen and copies based on the book hands of the ninth and tenth centuries. Johnston noted that: 'Children were being set the hopeless task of copying with pens, on paper, letterforms made and partially evolved by gravers on copper plates'. He urged that the copies should be written with the same type of nib supplied to the children and that they should be reproduced photographically, not engraved.

Photo-litho of a preliminary and unfinished drawing of Edward Johnston's typeface for the London Underground Railway. Reproduced by permission of the St. Bride Printing Library.

Edward Johnston and the origin of print script

Priscilla Johnston reported that nothing was done about her father's report until 1913, when Johnston repeated the same proposals at an LCC conference. No details of this conference can now be found. He may well have suggested what he had proposed in the past: that children should learn the skeletal forms of letters first, to be followed by letters with broad-edged nibs to give gradations of curves and thick and thin strokes (when properly used). The consequences of this meeting, however, were beyond Johnston's control. Without further reference to him, it was decided to adopt the form of simplified *block letter* called print script. Johnston has often been blamed for involvement in the introduction of print script. It has been suggested that the typeface that he designed for use on the London Underground Railway might have been used as a model for this alphabet but this would certainly not have been at his instigation. Anyhow, there were already plenty of precedents for simplified letterforms. Print had long been taught as part of mapping skills (see page 51).

The formal book hands, such as those modified by Johnston into his Foundational Hand and prescribed by Hewitt in his children's copy books, might not have proven particularly successful as a basis for everyday writing either. They were not built for speed. Johnston, who was anything but didactic, is said to have realised this, saying regretfully that these would never lead to rapid handwriting and that there was a need to compromise.

Graily Hewitt

Graily Hewitt was a pupil of Edward Johnston. He held stronger views. 'Ever since the invention of printing,' wrote Hewitt, in the preface to his *Oxford Copy-books*, 'Cursive handwriting has lacked the steadying influence of the formal or book hands and the authority of the standards they supplied'. He explained that his model derived chiefly from the Spanish scribe, Lucas, and the Venetian, Palatino. The forms, he said, were easily recognisable but: 'It is in the method of making and joining them that we have parted from the traditions referred to. And for this the modern pen is chiefly to blame. It is fine and pliable. The medieval pen was comparatively broad and stiff. On the subject of joins Hewitt remarked: 'Today the connecting stroke between the letters of a word has been insisted on until it has become a fetish. Of old it was only used when convenient, the letters were made one after another and connected automatically by bunching or clamping together'. As early as 1916 Hewitt was saying that: 'Since the coming of the typewriter rapidity cannot, even in commercial places, be called the first essential in handwriting'. He extended his views on speed, blaming modern education: 'Where the exercise

GRAILY HEWITT'S LETTERFORMS

x e x e x e x e x e x e x e

x em th ty fr rn em th ty fr rn

That apart from this the making
too independent of their history , as

Above: From Graily Hewitt's 'Oxford Copy-books' and an example of his handwriting, both reproduced permission of Oxford University Press. Below: A page from 'Handwriting: Everyman's Handicraft', published by the Chiswick Press in 1916.

abcghklmnoqrsuvvvwwyyz

dessijptxx

CEIJLOSUVZ

BDFGKMNPQRTWXY

AEFH?!

It is indeed a much more truly religious duty
to acquire a habit of deliberate, legible, and
lovely penmanship in the daily use of the
pen, than to illuminate any quantity of texts.

of memory is discouraged and all teaching administered to the accompaniment of note taking'. Note taking should not come into the category of handwriting at all: 'We do not teach a child to read and then estimate the goodness of his reading by the pace he can gabble'.

According to Alfred Fairbank, Hewitt's book, *Handwriting, Everyman's Craft,* was published in 1916 by the Chiswick Press. A page from it appears opposite, giving an example of his model as well as his views on the sanctity of writing. In his book, *Lettering*, published in 1930, Hewitt again recommended a return to the broad-edged pen for children. Like many craftsmen of his day, influenced by Ruskin and William Morris, he tried to impress on educators the value of using handwriting as an artistic and creative outlet in school.

His admiration of the more formal letters of the sixteenth century, led Graily Hewitt to recommend a semi-joined script for children: one based on the separate letters used by scribes for a different purpose in a different age.

am an ap ar au ay
ci ce ie in di de
ei em en [em en]ex
hi mi ft tu often

Natural ligatures only
are used — all other
letters are combined into
words by close-setting

An illustration from Hewitt's 'Lettering' shows how he grouped together natural ligatures to show how a semi-cursive hand could be developed from a model based on the more formal letterforms of a book hand.

On the other hand, Hewitt's practical advice was sound. Of desks he wrote: 'The desks for schools are necessarily adapted to general use in class. Yet for writing, if they could be adjustable to a slope of 45 degrees they would be better. ... And his work need not be horizontal in front of him. I think this is a matter in which the individual may be left to adopt the position most comfortable to himself, for rigid lines tend to force the right elbow crampedly into the side'. Of pen hold he wrote: 'As to the actual position of the hand in writing there has been too much dogmatism and it should be left more to personal choice'. This attitude did not stop him from giving precise instructions for a pen hold suited to the use of a broad-edged pen.

Hewitt sensibly noted that strong lighting can be too much for black and white work and that eyes should be at least a foot away from work, saying in conclusion: 'Every consideration to comfort and ease assists speed.'

Steps towards print script 1916–1922

A meeting of the Child Study Society took place in April 1916. It was attended by teachers and by the Chief Inspector of the LCC. Subsequently, schools began to experiment with their own versions of print script. The Board of Education's progress report, in 1923, explained that: 'The promoters of the present movement in favour of print script as a substitute, wholly or in part, for the ordinary cursive writing were influenced in the first place by the consideration of its advantage as a method of teaching beginners'. The advantages were:

'That by the adoption of print script for writing the need for two alphabets would disappear, and the reading and writing lessons would, from the first, help each other.

'Owing to the simplicity of the forms of print script characters, consisting entirely of straight lines and circles, or portions of circles, it was expected that they would be more readily learned than the ordinary cursive forms, and would be written by young children with greater ease and accuracy. There would be fewer bad writers.

'With print script the combination of letters into words presents no difficulty. Children whose powers of reading extended into narrative were still frequently restricted in writing to words presenting easy combinations of letters owing to the strain on a young child's finger and arm muscles involved in the effort to write whole words in a single continuous movement.

'The print script alphabet consisting as it does of the skeleton forms or essential elements of our modern print or script alphabet, could at a later stage be developed without difficulty either into an ordinary running hand, or formal script such as is usually taught in art schools'.

Teachers who had (briefly) adopted the new method, praised it for neatness and legibility, improving spelling, and improving exercise in English: 'On account of the greater ease of the mechanical work involved'. The question of speed was one of the first objections raised after, surprisingly, tests had shown that over the age of nine, cursive was slightly more rapid. Another point raised was the fear that print might not be acceptable to business men and other employers and that it would handicap children leaving school. This suggested that people were seriously considering that simplified, separate letters might take over from a joined hand altogether. Other worries included a loss of individuality in scripts, and that those who only learned print would find it difficult to read mature cursives.

The suggestion was that by ten or eleven years old children should be able to print adequately: 'They will then, if left to themselves, in rapid writing, show a tendency to link together certain letters, where the end of one

approaches closely to the beginning of the next and this tendency may be permitted, and even encouraged, so long as the joinings do not materially interfere with the appearance of the writing. While saying that, at this stage the print might be converted into a cursive, by modifications, to some of the letters. Such a course may possibly increase the speed to a certain extent, it undoubtedly decreases the legibility and beauty of the handwriting. In consequence nearly all teachers should check the tendency to join, except in the simple cases where letters link naturally'.

A scheme from Leicester was included where the letterforms were nearer to Johnston's ideas. They used natural joins, and progressed to a broad-edged nib and more formal letters. They called this style *manuscript* not *print.*

April - April : Hungerford - Hungerford
term - term : Question - Questionnaire :
often - often : writing - writing : trusty .

manifest manifest . spectrum spectrum
transport - transport : watering watering

arrange arrange · characters - characters
preferable preferable repetition - repetition

Bideford - Bideford Edinburgh Edinburgh
Halfway - Halfway Polly, Molly Polly, M.

The Board of Education's report included another radical suggestion: 'It is found that progress is facilitated by the abolition of guide lines which, though they may have been necessary for the more complicated forms of ordinary copybook writing, are not needed for the simple forms of print script. Plain paper or single lined paper should therefore be used from the start'. Even before the results were published in 1923, print script copy books were being produced. The models varied in proportion and slant, but simple round, rather than oval, letters were popular, leading to the name *ball and stick* writing.

Handwriting reform

David Thomas was director of Education for Carnarvonshire when, in 1918, he wrote his book, *Handwriting Reform*. He described the state of handwriting at a time of great change, expressing his own views as well as referring to those of other acknowledged authorities. He agreed with Dr J Gunn, author of the *Infant School,* about paper position – that this should be immediately to the right of the medial line of the body, but not with Dr R Rusk, who had written in 1912 in an article entitled *Position of Copybooks* that the paper should slant. Pen hold was dealt with in a traditional manner, with clear instructions on pen angle. Upright rather than slanting letters were recommended.

BAD POSITION.

GOOD POSITION.

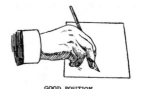
GOOD POSITION.

David Thomas noted that: 'For many years it has been the practice in elementary schools to insist on the connecting stroke between the letters of the words and to require the pupil to write the whole word without lifting the pen from the paper. This cannot be defended on the ground of convenience, because adults usually raise the pen two or three times in the body of the word. ... It is a great strain on the hand and arm to attempt to keep a constant pressure on the paper for all strokes. Raising the pen or paper removes this strain'. Hand and arm movements were also analysed in the interests of legibility, speed and reducing muscle fatigue. Thomas quoted Professor Shelley's views on joins, concluding that: 'Connecting strokes tend to make words similar, whereas to distinguish one word from another we require diverse elements'. He used Dr Kimmins' speed tests that had been published in *Child Study* in 1916 to try to prove that print was faster than the old cursives.

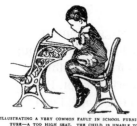
ILLUSTRATING A VERY COMMON FAULT IN SCHOOL FURNI-TURE—A TOO HIGH SEAT. THE CHILD IS UNABLE TO REST THE LIMBS ON THE FLOOR, AND LEANS OVER ON THE DESK FOR SUPPORT.

ILLUSTRATING TOO SMALL A DISTANCE BETWEEN THE SEAT AND DESK, CAUSING PRESSURE ON CHEST AND STOMACH.

ILLUSTRATING A DESK AND CHAIR TOO SMALL FOR PUPIL' SIZE, CAUSING CRAMPING OF THE LOWER LIMBS.

These drawings were taken from photographs in Dr WF Barry's 'Hygiene of the Schoolroom'.

Lines and left-handedness

David Thomas reported that: 'A movement has been gaining force lately in favour of the total abolition of lines at all stages'. He sought pseudo scientific explanations to justify this such as Kimmins' statement that: 'Anything which

substitutes for the subconscious automatic guidance of the muscles by their own nerve impulses a sustained tentative effort, involving another sense organ, must necessarily embarrass the speed and accuracy of production'. This seems a rather extreme interpretation of Dr Maria Montessori's theories which were also discussed by Thomas under the title the *Motor Memory in Writing*.

Then from *Newsolme's School Hygiene* came: 'Only thick lines are permissible midway between the lines of script and not to be touched by any letter; they are only for the orientation of words. ... Although writing is taught as a visual performance this is objectionable for ocular reasons. The eye only being necessary to keep the lines straight, writing should be learned by muscular sense, as a typist learns to work without looking at the keyboard'.

Differing views on left-handedness appeared. These ranged from teachers who asked whether it was desirable to make such boys use the right hand exclusively in writing and in manual work, to a certain follower of Montessori who stated categorically that natural left handers should not be forced to write with the right hand: 'Evidence has been accumulated which establishes the fact that this is a fertile cause of stammering'. A Miss Thompson added that the accepted theory by psychologists at that time was that: 'A person is right or left-handed according to the branching of the arteries carrying the supply of blood to the brain It has been found by investigation that left-handed children who have been made to write with their right hand never in later life reach the point where they can write with any degree of speed and ease'.

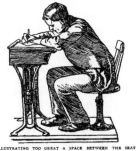

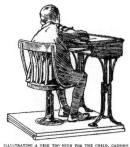

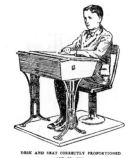

ILLUSTRATING TOO GREAT A SPACE BETWEEN THE SEAT AND DESK, CAUSING PUPIL TO STOOP TOO MUCH, INDUCING ROUND SHOULDERS.

ILLUSTRATING A DESK TOO HIGH FOR THE CHILD, CAUSING ELEVATION OF THE RIGHT SHOULDER IN WRITING, AND A CORRESPONDING CURVE IN THE SPINAL COLUMN.

DESK AND SEAT CORRECTLY PROPORTIONED AND PLACED.

Thomas quoted Welpton's advice on posture from his 1908 'Physical Education and Hygiene'.

In praise of print-writing

David Thomas went on to describe *Print-writing* as: 'A complete departure from the older systems of handwriting. It discards the script letters elaborated by the copperplate engraver and substitutes the simple and artistic Roman characters in which all our

> Dr. C. W. KIMMINS, Chief Inspector under the London County Council, says:
> **"There are no failures** in Print-Writing as in the case of ordinary script."

books are printed. ... Thus print-writing is not a mere change of letterforms. It is a scientific system of penmanship'.

Dr C W Kimmins, Chief Inspector under the London County Council, had no hesitation in backing the new model. It is therefore perhaps unkind to note that Thomas recommended print-writing for defectives and left handers.

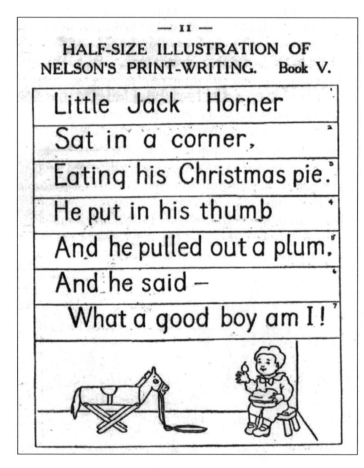

— II —

HALF-SIZE ILLUSTRATION OF NELSON'S PRINT-WRITING. Book V.

Little Jack Horner
Sat in a corner,
Eating his Christmas pie.
He put in his thumb
And he pulled out a plum,
And he said —
What a good boy am I!

Above: A statement written by Dr C W Kimmins, the Chief Inspector of Schools for the LCC, as an endorsement for Nelson's 'Complete Print-writing Course' (also referred to as Manuscript Writing).

Left: Several pages from the six books of Nelson's 'Complete Print-writing Course' appeared at the end of Thomas' book on handwriting reform. Notice that words were written between the lines rather than on them. This is the way medieval scribes once wrote but it is unusual to find this method used for teaching children.

Retraining from joined to unjoined writing

David Thomas was convinced of the virtues of *Print-writing*. He showed how to 'retrain' pupils who already had an adequate joined-up handwriting. They were forced back to separate letters. This practice was clearly remembered by GMN in 1922 when she was twelve years old, and by JPS in the early 1930s, at the age of nine. He has not forgotten his indignation at what he saw as having his 'own script' taken away from him. Yet Thomas deplored

contemporary attitudes to uniformity and on speed felt that: 'He should learn to write rapidly because some day he will possibly be a busy man'. He also asked: 'Why cannot the child be allowed the freedom which the adult enjoys of lifting the pen whenever he finds it a convenience? He would then, while still at school, develop a style he would continue to use afterwards'.

These two examples illustrate Thomas' reforming zeal. Above: A competent cursive reduced to a small tight print. Left: The three stages of 'retraining' another hand, starting from a less competent writing. What Thomas called 'improvement due to printing' might, in some circumstances, make it easier for the reader, but could restrict the writer to immature separate letters for many years to come.

Used, blotted copy books, that might be considered worthless, sometimes reveal useful information. This example from the early 1920s showed that 'manuscript writing' or 'print script' was not universally approved of. This pupil tried to simplify her writing, but was corrected by the teacher, who thereafter replaced the exemplar with her own style of cursive.

No 1. How many halfpence in
half of £1·14s. 1d?
½ of £1·14s 1d = £1·14s 1d ÷ 2

£ s d
2 ⟌ 1 · 14 · 1
 17 · 0½
 12
 204
 2
 409 halfpence Ans.

14 Forest Rd.
Bristol.
Nov. 27th 1920.
Dear Tom,
 On Saturday next I am
eight years old and I am to
have a birthday party I hope
you will be able to come.
 Mother is writing to ask if
you may come to the party,
also if you may stay a few
days afterwards.
 Your sincere friend,
 Bob.
Master Tom Ray,
 Queen St,
 Weston.

Examples from the early 1920s print script copy book illustrated below. They retain a delicacy of penmanship sadly lacking in many print models of the next half century.

THE CHANCERY SCRIPT

Chancery script from Giambattista Palatino's 1544 manual, 'Libra nel qual s'Insegna a Scrivere'. Below: From 'Il Modo de Temperare le Penne', written by Ludovico degli Arrighi di Vicenca in 1523.

Contemporary attitudes to, or style in, painting and architecture allied to general artistic and literary thinking, filter through into fashionable taste and eventually make themselves felt in letterforms. 'Reaction (against the degraded Copperplate) was inevitable', wrote Roger Fry 'and it declared itself more or less hand in hand with the Pre Raphaelite movement in painting: it seems also very likely the contemporary move in poetry, which was founded, like the painting, on the example of the Lake Poets, broke loose from it and took on a wider romantic expression'.

Mrs Bridges' handwriting manual was one consequence of this movement. The contributions of the letterers Edward Johnston and Graily Hewitt followed soon after. Each of these three acknowledged their debt to the particular classic hands that had influenced them. Fry wrote of Mrs Bridges: 'The hand taught in that book was what is sometimes called Italianised Gothic. It was illustrated with plates from Michael Angelo and a sixteenth century reformation scribe. Edward Johnston took for his basis the half uncial of the eighth century, but influenced by the practical needs of his students, passed from that to the late Carolingian miniscule, which he now calls the foundational hand. Later he has been working with a more Italic script'. The italic that Johnston was experimenting with bears little resemblance to that developed by Alfred Fairbank, nor that taught to calligraphers today. It was altogether a more solid hand, and as such probably influenced the forward sloping handwriting model produced by Graily Hewitt. The hands most admired by Fairbank and his followers were those of Arrighi, Palatino and Tagliente.

CHAPTER 5

Initiatives and models from 1930

IN THE YEARS leading up to the outbreak of war in 1939, there was a flurry of activity in the field of handwriting. The educationists were promoting print script as easy-to-teach alphabet for young children. In some circles it was even put forward as a complete new handwriting system. There were, however, many others, particularly those involved in the arts, who held quite different views. Foremost among them were Alfred Fairbank, the calligrapher, and a committed writer of the italic hand, and Marion Richardson who had already made a name for herself as an imaginative teacher of art before developing her ideas about handwriting

The italic handwriting revival

The word italic, as a typographic term, means 'narrow and forward sloping letterforms'. It was used to describe the Italian letterforms of the printer Aldus Manutius, forms that in turn had been influenced by contemporary chancery hands of the fifteenth and sixteenth century. In the second half of the twentieth century, italic was used to describe a wider variety of forms of handwritten letters, resulting from modern interpretations of classic scripts. Among teachers, the word 'italic' developed an emphasis on the first syllable.

To understand how the modern calligraphic revival arose, it is necessary to go back to the final decades of the nineteenth century. As Roger Fry wrote in in 1926: 'At the end of the last century schools of writing arose which deliberately founded themselves on a return to old scripts'. Fry attributed this to: 'A reaction against the ultimate degradation in lawyers offices, from vulgar clerks who scrupulously perfected the very most purely ugly thing that a conscientious civilisation has ever perpetrated ... and the soulless models of the school copybooks'. The movement was, he proclaimed: 'A revulsion from the careful elegant style which most gentlefolk practised a hundred years since as shown in the epistolary correspondence of our grandsires'.

Undoubtedly Fry and many others felt strongly about such matters, pouring scorn on Copperplate-based letterforms, in a way that has repeated itself throughout history – and still occurs today. What has been deemed fashionable in letterforms a few decades earlier will first be scorned, then ignored for half a century or so and finally revived as a classic. The hands that Fry deplored are now praised as calligraphy.

ALFRED FAIRBANK'S WRITING CARDS

THE DRYAD WRITING CARDS

By ALFRED FAIRBANK, C.B.E.

Fellow of the Central School of Arts and Crafts
Author of 'A Handwriting Manual'

The pen should be held so that it makes the thinnest stroke at an angle of 45° to the writing line (see figure above). The right elbow should be held a little away from the side of the body. The pen shaft must *not* be pointed to the shoulder. Good handwriting is rhythmical. The exercises in lines 2 to 8 of Card No. 1 will help to develop rhythm and may well be practised frequently. As joins are learnt they may be added to the exercises of Card No. 1.

All letters except *d, e, f, p, t,* and *x* should be made without lifting the pen from the paper. As speed in writing develops, diagonal joins may connect up easily from previous letters to the letters *a, c, d, g,* and *q,* and *b, h, k,* and *l*; and also *d* may be made of one stroke.

The following square-edged pens, made by Geo. W. Hughes, were used in writing the exercises: Cards Nos. 1 to 7, 'Violin Pen No. 1196'; Cards Nos. 8 to 10, 'Flight Commander Pen No. 1240B'; titles of cards, 'Durador Pen'.

These cards grew out of the interest in the teaching of handwriting of Mr. J. Compton, C.B.E., when Director of Education for Barking, and head teachers of Barking schools, to whom grateful acknowledgements are made by the author.

THE DRYAD PRESS, ST. NICHOLAS ST., LEICESTER
London Showroom: 22 Bloomsbury St., W.C.1

Exercises from Alfred Fairbank's writing cards.

nununununununun ∧ *un nu un nu u*

mamamamamam nun nun nun nu

fa fo oa oo ta to · ∧ *cloud rain snow h*

oa oc od oe og oi brook stream water

Alfred Fairbank

Many illustrious figures were involved in the italic movement, among them such leaders in the field of letterforms as Sydney Cockerell and Stanley Morison the typographer, but it is the work of the calligrapher Alfred Fairbank that is most significant as far as education is concerned. It was due to his initiatives above all that led to the introduction to italic handwriting in schools, first in Great Britain and subsequently in many other countries.

In 1928 Fairbank designed a set of ten italic cards for use in schools in Barking. He acknowledged that: 'These cards grew out of the interest in the teaching of handwriting of Mr. J. Compton C.B.E., when Director of Education for Barking, and head teachers of Barking Schools'. The Dryad Press published these cards in 1932. They were described as: 'Illustrating a simplified italic which would have been ideal for an experienced teacher to use. There are no personal quirks in the letters and these cards would have guided children into a writing that could develop, if encouraged, into an efficient personal hand'.

Fairbank's *Handwriting Manual*, first published in 1932, extended the details of the teaching of handwriting. He dealt at length with such matters as legibility, beauty, unity, speed and expediency. Fairbank felt that the italic model provided the ideal solution. Writing, as he said, is performed by movements. This sentiment is expressed in his famous phrase: 'It is a dance of the pen'. He provided practical details with the cards and even more in his manual. Fairbank made his views on the print script movement clear. He combined historical precedents with his own preference, saying: 'What the reformers failed to realise was that the Renaissance history had taught a lesson namely that the Roman letter is one written with many pen lifts and that its fluent counterpart, developed in the fifteenth century is italic. Instead of a model not designed for fluency and indeed against it, a more sensible course is to teach a simple italic hand'.

Donald Jackson wrote in 1981, some fifty years after the event: 'Alfred Fairbank set about with reforming zeal to make his own particular contribution to the revival of this style of writing for more general use. Those early writing cards, first published in 1928, were the forerunners of many Italic cursive exemplars, and his handwriting manual continues to encourage the introduction of the Italic hand in many schools around the world, as does the Society for Italic Handwriting founded with his support in 1952'. In fairness to Jackson his next comment should also be recorded: 'Today, in the age of the ball-point pen, it may be less clear what model a child should follow, for the ballpoint in its present shape is ill-suited to the shaded forms of the square-cut quill'. This issue will be discussed again on pages 112–121.

The spread of print script

Educational pronouncements, together with designers' claims for their particular version and publisher's advertisements, trumpeted the benefits of the new simplified letters. 'In the New Age which has just opened, the demand for National Efficiency is more insistent than ever before,' proclaimed Nelson when advertising their *Course in Print Writing* in 1918 (see page 66). They continued: 'Every teacher who raises the standard of handwriting is doing National Service by making the Nation more efficient'. It was an emotive appeal, the rhetoric reflecting the mood at the end of the First World War.

'An evolution in modern writing' is how A G Grenfell, an Oxford lecturer and distinguished headmaster, described the print letters. His *Sloping Script Copy Book* was published by Philip and Tacey in 1924. In the introduction, under the title 'Reasons and Hints for Writing Sloping Script', he went on to claim: 'This is a carefully written answer to criticisms of those who have never learned this simple, legible hand, which is steadily replacing Cursive in many English Schools throughout the world. It is worth reading by all teachers who are hesitating as to whether to make the plunge or not, as it deals seriatim with the conventional arguments against Script by appealing to actual experience gained by five years trial'. It is clear from his copy books that Grenfell meant there to be no progression to a joined hand.

In many schemes, however, print script was meant as a preliminary to some kind of semi-joined or joined-up writing. This concept was well illustrated by a series written by a Miss C A Wells, published by Philip and Tacey in 1929. It was called *The Sherwell Progressive Handwriting Cards – From script to cursive.* Advertised as a scientifically designed series, carefully graded for developing a clear, legible running hand from script (print writing), the early cards illustrated a clear, upright print. The next stage showed separate letters with exit strokes as an introduction to what can only be termed a semi-joined hand. The joins were not very consistent on the exemplars. Some letters were not designed to join at all, and others appear to be resting against the next letter rather than joining to it (see opposite). Yet this was a step forward in the development of simplified letters, and a link between the plain print letters and those that Marion Richardson introduced in 1935 (see page 76). The Sherwell cards were still available in 1960. By then they stated importantly: 'On LCC Approved List'.

Numerous print script (or manuscript) copy books were available from 1920 onwards. Until sans serif typefaces began to be used to represent print script letters, the models, although sometimes inconsistent or idiosyncratic, reflected the differences in personality and skill of those who designed them.

EARLY PRINT SCRIPT MODELS

address is not printed, put it clearly in

the top right hand corner whether you

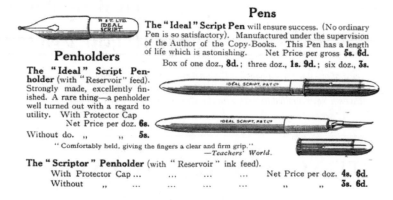

Pens

The "**Ideal**" **Script Pen** will ensure success. (No ordinary Pen is so satisfactory). Manufactured under the supervision of the Author of the Copy-Books. This Pen has a length of life which is astonishing. Net Price per gross **5s. 6d.**

Box of one doz., **8d.**; three doz., **1s. 9d.**; six doz., **3s.**

Penholders

The "**Ideal**" **Script Penholder** (with "Reservoir" feed). Strongly made, excellently finished. A rare thing—a penholder well turned out with a regard to utility. With Protector Cap
Net Price per doz. **6s.**
Without do. „ „ **5s.**

"Comfortably held, giving the fingers a clear and firm grip."
—*Teachers' World.*

The "**Scriptor**" **Penholder** (with "Reservoir" ink feed).

With Protector Cap Net Price per doz. **4s. 6d.**
Without „ „ „ **3s. 6d.**

Above: Grenfell's 1924 slanting script model. He recommended it for all ages calling it an evolution in modern writing. Special pens were designed for use with this script.
Below: A second stage model with the separate letters showing exit strokes from Miss Wells' 1929 'Sherwell Progressive Handwriting Cards'. These letters led easily to a joined hand. Both schemes were published by Philip and Tacey and all the illustrations come from their catalogues.

a b c d e f g h i j k l m n o p q r s t u v w x y z.

abcdefghijklmnopqrstuvwxyz.

A B C D E F G H I J K L M N O P Q R S T U V W X Y Z.

Matthew. Mark. Luke and John.

Bless the bed that I lie on.

MARION RICHARDSON'S SCHEME

Dudley Writing Cards

In 10 Sets by
MARION RICHARDSON
of the London Day Training College
and the Dudley High School

LONDON: G. BELL AND SONS, LTD.
YORK HOUSE, PORTUGAL STREET, W.C.2
GLASGOW: W. & R. HOLMES

O Q C S G
n m h k p
Son Daughter
Bowling hoops
George v 1910
Ring a Ring o' Roses
Paddle your own canoe.

Above: The cover and one card from Marion Richardson's original 'Dudley Writing Cards', published in 1928 by G Bell and Co. Below: The covering of the 'Writing and Writing Patterns' scheme listing the contents. It was first published in 1935 by the University of London Press.

WRITING & WRITING PATTERNS

By MARION RICHARDSON

SPECIMEN SET OF COMPLETE SCHEME

─────────────── CONSISTING OF ───────────────

BOOK ONE Twenty pairs of copies.	BOOK TWO Ten pairs of copies.
BOOK THREE . . . Twelve pairs of copies.	BOOK FOUR Twelve pairs of copies.
BOOK FIVE Twelve pairs of copies.	BOOKLETS A and B.

SPECIMEN CARD . . Each pair of copies contained in Books One to Five, i.e. pages 1a and 1b, 2a and 2b, etc., may be obtained separately as a card for individual class use.

TEACHER'S BOOK . . Describes the Method and Materials.

UNIVERSITY OF LONDON PRESS Ltd.
Warwick Square, London, E.C.4

The Marion Richardson solution

In retrospect it could well be argued that Marion Richardson made the most significant contribution to the development of handwriting in the twentieth century. Professor Julian Brown, while lauding Johnston for his spontaneity and wide range of scripts and attitudes, spoke of her achievement in this way: 'Marion Richardson, as the author of a solution in which the full cursiveness of English Roundhand has been preserved and its style improved in the light of sixteenth century models, commands from at least one palaeographer the same kind of admiration that (Niccolo) Niccoli commands'. Marion Richardson combined two skills that uniquely qualified her to develop a handwriting scheme: she was an art teacher by training and author of an important book, *Art and the Child.* In 1986 Professor Swift, who has made a study of her life and work, wrote: 'The name of Marion Richardson is known to most art educators either as a charismatic proponent of child-centred art, or for her linking of pattern forms and handwriting'. According to Clare Bevan, in an article in 1985: 'Marion Richardson felt that print script produced a staccato movement and that it did not lead naturally to a cursive hand and lacked character. She agreed with Johnston's principles and decided to look back'. She was influenced by the Renaissance writing masters, and extracted from them what she considered the elements necessary for an everyday handwriting, appropriate for children in the twentieth century. Advised by Edward Johnston, whose student she had been, Richardson's *Dudley Writing Cards* were first published in 1928 by George Bell and Sons.

In 1930 Marion Richardson was appointed as an inspector of schools with the LCC. This meant that her methods of both art education and handwriting could be put into practice and reviewed in a wider context. She soon became aware that the broad-edged pen was not a particularly suitable tool for very young children. At about the same time she also became interested in the pre-writing scribbles of young children. Marion Richardson said in her revised scheme, *Writing and Writing Patterns* published by London University Press in 1935: 'These cards and books are designed to give a child practice in the essentials of a simple running hand, which will serve him throughout school life and be the foundation of a good adult hand. A free cursive writing employs only easy movements of the hand and arm, such as are used in primitive forms of decoration and childish scribble'. The patterns were such an integral part of her method. Swift described how: 'These exercises were intended both to develop pattern sense in line, mass and colour, and enhance writing quality through the consideration of balance, symmetry and rhythm. Six basic shapes were used that derived from the letters of the alphabet'.

It is this combination of her knowledge of the history of writing with her observation and research into the needs of young children that made her handwriting books so successful. She understood physiological aspects of the task of writing, saying (of six year olds): 'By this time he will have begun to make use of writing, and will be ready to form a more exact muscular memory of the letter and between letter shapes'. She chose the wording of her examples with care to include common letter combinations. In conclusion she wrote what so many in the next half century chose to ignore: 'It need hardly be said that these copies are not intended as models of perfection. They are ordinary writing written with an ordinary pen. Their object is to teach a swift and simple running hand which a child need never have to unlearn, but which will grow as he grows into something that is increasingly his own'.

Despite Marion Richardson's modest description of her books and cards they are in themselves items of beauty. The small booklets that relate her patterns to the letter families, are just the right size to be attractive to young children. The line quality of her own consistent written forms give out a reassuring and uncomplicated message to young writers, and her instructions to teachers impart an enthusiasm for the subject that she understood so well.

Marion Richardson gave sound advice about balancing the issues involved in the task saying: 'Learning to write should be a happy experience and children should not be expected to give their whole attention to penmanship. It is necessary to distinguish between the different ways in which a child uses handwriting remembering that a free live quality of line is always to be valued above mere neatness'. Practical hints concerning the teaching of handwriting abound in her books.

The *Writing and Writing Patterns* scheme was used for over fifty years, influencing several generations, leaving its mark on English handwriting. Not only that, but other countries also copied her work. Alvhild Bjerkenes introduced a similar model in Norway in the 1950s and Denmark adopted it for a time (see page 173). This introduced a script that was rounder and more relaxed than the cursives of most of continental Europe and the US.

Marion Richardson's letterforms were, however, attacked by those promoting a more sophisticated italic hand. They failed to understand the advantages of a beginner's model with slightly rounded strokes, making it easier for young children, and helping them to join their letters at an early age. Her copy books were carefully graded leading pupils on to the broad-edged nib and narrower slanting letters. Richardson considered that: 'A child needs a model not only when he first learns to write by but also to protect him from slovenliness and affectation while his writing is forming'.

MARION RICHARDSON'S LETTERFORMS

18 b

The Capital Letters
Aa Bb Cc Dd Ee
Ff Gg Hh Ii Jj
Kk Ll Mm Nn
Oo Pp Qq Rr Ss
Tt Uu Vv Ww
Xx Yy Zʒ
& Small Letters

S J S J S J

u l i t

WRITING & WRITING PATTERNS, SET B
University of London Press Ltd., Warwick Square, London, E.C.4

Above: Alphabets from Book One and child-sized pamphlets from Marion Richardson's scheme.
Below: Exemplars from Books Two and Three showing the progression to a broad-edged nib.

Barber, barber,
shave a pig,
Sing a song of sixpence,
Pocket full of rye;
Four & twenty blackbirds

79

CHILDREN'S EXAMPLES FROM THE 1980s

A swarm of bees in June
Is worth a silver spoon.

Friday 26th November.
What I would like on my Christmas
Table.
I like Christmas pudding with c...
custard on it as long as it is no...
lit. I like it because mummy...

a giraffe. His neck and legs had been
stretched out really long. And that
is why from that day onwards giraffe...

Examples collected in the 1980s from a school that used Marion Richardson's 'Writing and Writing Patterns'. The two examples on the top line were written by the same boy at five and at six years old. Continuing downwards, they are written by girls aged seven, eight, nine and ten years old. They illustrate considerable personal variations.

But I am at play,
All merry and gay!

rains alot more, and this is
the Nile begins, a long way a...
from most of the farms. Dam...
have been built to stop som...

bicycle large wheel bicycles are the best
these give you more support attached to
these can be two small wheels giving you

DEVELOPMENT INTO AN ADULT HAND

> The race took so long, the riders having to go round the course so many times, that people went on complacently with their tea, only looking out occasionally to see how things progressed, watching the riders go by — one with bright red braces, one in a blue cotton coat, two middleaged men in their best

> He who has been instructed thus far in the Science of Love, & has been led to see beautiful things in their due order & ranks, when he comes toward the end of his discipline, will suddenly catch sight of a wondrous thing, beautiful with the absolute Beauty; — & this, Socrates, is the aim

Above: Examples of mature hands from Marion Richardson's 'Teacher's Book' – a girl of seventeen and very rapid writing by an adult. These show how she hoped and expected writers who followed her scheme would develop. Unfortunately many schools only used the early exemplars and continued with them far too long. They either did not possess or ignored the 'Teacher's Book'. Some adults therefore kept an immature, over round hand, or exaggerated the weakest of her letters, the open 'b' and 'p' as illustrated below.

> still in pan. Put in greased tin and bake

> If it sounds fanciful about reshaping our

The Montessori influence

Dr Maria Montessori (1870–1952) began her enlightened work on early childhood education at the beginning of the century, in Italy. Montessori's attitude to teaching handwriting, informed by her medical training as well as her observation of young children, was many years ahead of her contemporaries, and her methods deserve respect and serious consideration today. Despite the alterations in educational thinking and priorities that have taken place in primary and secondary education in the intervening years, the Montessori philosophy can help us to understand and overcome some of the most pressing problems in our classrooms.

The following quotations were gleaned from various publications including Dr Montessori's own notebook (1914) and *The Discovery of the Child* (1949): 'We should realise the the immense strain which we impose on children when we set them to write directly without motor education of the hand', and: 'Even though we use the same alphabet the motions we make are so individual that each one has his own particular style of writing, and there are as many forms of writing as there are of men'.

She described teaching handwriting as 'Stocking the muscle memory' and described how: 'Writing is often the result of painful and disagreeable preparation in school. It evokes the memory of dry effort, of pains suffered and punishment inflicted'. The sensitive stages, so fundamental to Montessori teaching, are defined as moments when a child is ready and best able to assimilate certain knowledge. They can be used as a general guide as to when children should start to write. She explained how a child of four or five might enjoy touching sandpaper letters with their eyes closed: 'If on the other hand the exercise is given to a child who is too old he will be more interested in seeing the letter which by now represents a sound and part of a word'. Her books describe in detail her suggested method for the multi-sensory teaching of handwriting. The only aspect that has needed modification is her original model, based on the cursives in use in Italy at the turn of the century. As different models became fashionable, so the letters have been modified to suit national styles.

One page cannot do justice to the work of this great educationist. Courses on Montessori methods are available worldwide, run by the International Montessori Association (AMI) and other groups. Montessori schools have always been popular for young children, and are increasingly valued by parents and education authorities who recognise the need, particularly for under fives, of a method which develops the necessary discriminations and hand skills to prepare infants for the tasks ahead.

Tracing sandpaper letters.

MONTESSORI TECHNIQUES

In 1913 Dorothy Canfield-Fisher, an American, described the Montessori apparatus, in a book called 'The Montessori Mother', as: 'A carefully designed trellis which starts the child's sensory growth in a direction which will be profitable for the practical undertaking of learning to write'. She noted: 'At four a child spends about a month and a half on the definite preparation for writing. At five usually a month. The child, it is true, has gone through a far more searching preparation for this achievement, traced the outline so often with his fingers that it is lodged in memory. So when, pencil in his well trained hand, he starts on an action already automated, he has done it so often that he could do it with his eyes shut'. Reading, Montessori believed, should come after letter recognition and word and sentence making with solid letters.

Tracing geometrical designs - note the slanting board.

Word building with cut-out alphabet.

EARLY MONTESSORI LETTERFORMS

MODERN MONTESSORI LETTERFORMS

Montessori models have altered throughout the century from the early letters, examples of which are shown opposite. Now they vary from country to country both in cursive and separate letterforms, in response to different national models. Top: American print and cursive from the 1997 Nienhuis Montessori catalogue. Centre: Wooden letters for continental Europe from the 1997 Gonzagoreddi Montessori materials catalogue. Below: Sand paper print script letters showing some of the specific pairs of letters (linked digraphs) taught to help link writing, spelling and reading, and modified Sassoon Primary letters with integral exit strokes that lead easily to a simplified joined up writing.

Summing up half a century of changes in letterforms

Great changes took place during these fifty years in the teaching of handwriting. As far as letterforms were concerned, schools changed from predominantly teaching traditional continuous cursives to equally predominantly teaching simplified letters, whether italic, Marion Richardson or print script. Barnard's (1968) views on this period ring true: 'I do not view the developments which have taken place since 1913 as separate efforts to create new styles but rather as progressive "movements", because the underlying unity is that they were inspired by the traditional roots of the subject. We must also remember that the measure of success of these "movements" was not only due to their link with historical traditions but because they blended with the educational climate of thought which prevailed at the time, and teachers were prepared to teach handwriting in that manner'.

The stylistic extremes are clearly illustrated by the letterforms below. In 1909, *The Children's Encyclopaedia* provided a comprehensive home-teaching programme. The lessons (see page 50), spread over several volumes, taught a continuous cursive. In contrast, by the time a revised edition came out, some fifteen years later, this subject was dealt with in quite a different way. Instructions were confined to the first volume. The letterforms were a simplified print script and the new model included some unusual typographic forms, not seen elsewhere at the time. These accentuate the transitional state of handwriting at the time. That such an influential publication should make such a fundamental alteration in a relatively short space of time is a useful indicator of what might have been happening in schools and homes throughout the country.

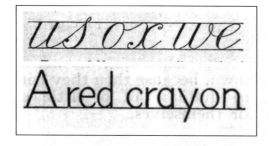

In 1909, 'The Children's Encyclopaedia' used Copperplate letters in a comprehensive series of lessons progressing through all eight volumes. (see page 50). This illustration shows the introduction of joining using two-letter words only. About fifteen years later in a ten volume edition of The 'Children's Encyclopedia' (note altered spelling although both editions were published in England) the model had been radically altered. Ball and stick letters were used with unusual typographic forms of 'a' and 'g', (see opposite). The lessons were confined to the first volume as if handwriting was now somewhat less important.

PRINT SCRIPT IN THE CHILDREN'S ENCYCLOPEDIA

SCHOOL LESSONS
Simple Learning Made Easy for Very Little People

WRITING—STROKES AND CROOKS

Now we'll make a little hill,
Much too small for Jack and Jill,
Now a path across we'll lay,
So we make a capital A.

A A A A A

Bopeep's crook, then Mother's meat-hook,
Make it carefully all the way.

Put the meat upon the hook,
So we make the little a.

a a a a a

Give a little stick to C,
So we make a capital G.

G G G G G

Little g is hard to write,
Watch me first, then off you go.
Like small o with a feather in his cap,
And a tail curling round below.

g g g g g

G for Goosey Goosey Gander,
g for the goose with her golden egg.

" Never mind," said Mother, " people sometimes find easier ways to write them, and here they are : "Oh, those are quite easy," said the twins, " we will always make ours that way."

a a a a a

g g g g g

ball doll drum

flag-pole, lamp-post

87

LETTERFORMS IN PRIMERS

READING WITHOUT TEARS. 25

P is like a man coming to you with a pack on his back

q is like a man going away from you with a pack on his back

WILLIE'S PENNY. 7

14. Willie saw that this was what he should do, and that very day he put his penny into the Penny Savings Bank.

15. At the bank a man gave him a book, in which the penny was put down. After that Willie took more pennies to the bank, till at last he had ten; then he was able to buy the bat and the ball he wanted.

2. Copy the following Lines :—

Twelve pennies make a shilling

Letters for reading and letters for writing

Another fundamental change was taking place over this period. Handwriting was being manipulated to conform to printed letters. The model on page 87 shows how some children were even being taught to write typographic forms of the letters 'a' and 'g'. When Civil Service script was the most usual model, concern might justifiably be expressed about the two very different sets of letters that young children would experience on school entry. By the middle of the century most written letters had been simplified, yet the push for similar letters for reading and writing was accelerating. Handwriting was increasingly being seen as a visual activity, and being confused with the letter-recognition aspect of reading. Apparently little thought was being given to the consequences. Forgotten were Montessori's words about the teaching of handwriting being the stocking of the muscle memory – the same for Fairbank's views about the undesirability of relearning before being able to join up. Ball and stick writing made the transition to joining difficult, but little attention was paid to this. It was neat, and neatness was important. The suspicion must also be that teachers had found print script easy to teach and did not want to look any further. These attitudes were to affect the writing of generations to come.

Opposite: Descriptions to aid letter-recognition from 'Reading Without Tears' published in 1872, and a page from the 'Royal Star Readers' (no 1) published in 1911, showing both type for reading and Copperplate letters for copying. Below: Stiff ball and stick letters from Ruth Steele's 1932 'Script House'.

A curved stick is of no use to Mr. Roundring. He can only use a straight stick with a hook at the end of it.

Changing attitudes towards the writer – left-handedness in particular
At the beginning of the century elementary schools were still laboriously
teaching a skill to fit a young person for the job of a clerk. By the middle of the
century, the view of handwriting as a subject had altered. It was beginning to
be seen as a tool for creativity. Other attitudes were also softening, towards
left-handedness for instance. Of the writing masters whose copy books were in
use at the beginning of the century, only Jackson had a brief reference to left-
handedness. Most children were prohibited from using their left hand and had
it tied behind their backs if they continued to offend. Only anecdotal tales
suggest otherwise. In Joyce Wilkins' *A Child's Eye View*, it was said of a stern
head mistress in 1909: 'She made us write our copy books on alternate pages,
first with the right hand and then with the left, and woe betide you if your left
hand writing was not as neat as your right. I suppose at the time the
neurologists were discovering the functions of the two hemispheres of the
brain, and it was considered advisable to train both sides equally. Baden Powell
published *Scouting for Boys* in 1909, and in that book he advocated using both
left and right hands for writing and drawing'. An elderly school inspector
enlivened a dull meeting in the 1980s by recounting a tale of his own school
days. He said that early in the century the usual punishment for any minor
misdemeanor was to write a hundred lines. The added twist was that, in his
school, the lines had to be written with the left hand: 'As I was an extremely
naughty boy I became quite competent at writing with my left hand'.

Robin Tanner (see page 99) wrote in 1952: 'We have reached the stage of
reason and understanding in our schools where no stigma is any longer
attached to that minority of naturally left handed boys and girls which will
always be there, considered at best an odd and awkward problem, and which
some decades ago was persecuted at the hands of teachers who desired
absolute uniformity in the classes they ruled'. Even so, not much practical help
was suggested as Tanner continued: 'There are differences to be accepted, and
the less attention is drawn to them the better. The left hander becomes so used
to adapting himself to modes of arrangements, customs, tools designed for
right handers that maybe he employs both hands rather more fully than the
right hander; but even so he will usually appear awkward to the majority –
and the majority have probably never wondered how they appear to him!'

This demonstrates the mid-century attitude – half way to the thinking on
left-handedness today. (In some countries rulings prohibiting the use of the left
hand persisted far longer.) There were still no initiatives for those who
experienced real problems – what today would be termed special needs –
though some teachers must have developed their own methods.

Variability of handwriting

In the space of fifty years, both the letterforms and the attitudes to the act of writing had irrevocably changed, as well as its usage. It became increasingly difficult to define a typical national handwriting as so many different models began to be adopted in British schools. To add to the diversity, there was often a marked difference in the scripts of those who were educated privately, those who attended grammar schools and those who had been educated in the old elementary schools.

Writing implements had altered considerably. The pointed quill or metal nib had imprisoned the writer in the uniform rhythm and thick and thin strokes of Copperplate. New pens gave more freedom to the writer at a time when there was a readiness to accept more individuality. It is interesting to note that the broad-edged pen was praised yet the fountain pen, fast replacing dip pens and infamous school ink pots, was often viewed with suspicion. This suspicion was soon to be transferred to ballpoint pens.

These examples illustrate how it became impossible to define a national style. MHW wrote a traditional hand in her early teens, but in her early twenties had developed a personal style lasting the rest of her life.

MHW at 15 years with a relief nib.

MHW in her twenties with a fountain pen.

MHW at ninety with a ballpoint pen.

EXAMPLES FROM 'A HANDBOOK FOR SCHOOLS'

There at the foot of yonder nodding beech
That wreathes its old fantastic roots so high,
His listless length at noon-tide would he stretch,
And pore upon the brook that babbles by.

ELEGY WRITTEN IN
A COUNTRY CHURCHYARD

There at the foot of yonder nodding beech

That wreathes its old fantastic roots so high,

His listless length at noon-tide would he stretch,

And pore upon the brook that babbles by.

ELEGY WRITTEN IN
A COUNTRY CHURCHYARD

These are the only models illustrated in 'A Handbook for Schools', first published in 1937.

CHAPTER 6

Educational attitudes mid-century

THREE SUBSTANTIAL official publications give the background to shifting attitudes to handwriting. They are the Board of Education's *A Handbook for Schools*, which was first published in 1934 and reprinted in 1937, a report from the London County Council's School Inspectorate in 1958, and *Primary Education,* produced in 1959. It is difficult to judge how much they influenced training and teaching practice. The copies used to extract quotations for this chapter were found on the shelves of a local teachers' centre, in 1980, and saved from destruction when it closed down.

The Second World War affected the entire school curriculum. The old discipline and conventions began to disappear and new ideas started to flood in. Some were beneficial but others may well have contributed to the decline of handwriting as it had been perceived during the first half of the century. The Board of Education's *A Handbook for Schools*, published before the war, stated: 'Of the teaching of handwriting it need only be said that the exercises at this stage should always have meaning. Most Infant schools find it advantageous to teach the children – who are at the same time learning to read – to use symbols which resemble those they see in print. Before they leave the Infant school the children should be expected to write at reasonable speed. Through their work in drawing and making patterns they should acquire the manual control that will help them later when the time comes for cursive writing. Written "Composition" as such does not belong to the Infant School, but some children enjoy putting their ideas on paper and should be allowed to do so'.

The London County Council's Educational Inspectorate gave their view of the situation in 1958, and to a certain extent reflected the new social scene. 'The present disquieting position of handwriting in schools owes something to the wartime dispersal of children, for not only did the children, now adolescent or adult, suffer but also the teachers who are now in the classroom'. The LCC report then asksed upon which style should their studies be based, saying: 'The tradition of the copperplate dies hard. Many teachers were taught these hands and it is obviously easier to teach what one has practised from childhood than to adopt a new method of writing in later years'.

Comments concerning style

Print script as a first model was not discussed in detail, but: 'The practice of children learning to write in the infant school who, on passing to the junior school are taught a fresh style of handwriting or who, even in different classes are compelled to follow different styles with successive teachers', was reported.

The advantages and disadvantages of Copperplate, such as ligatures, was discussed saying: 'It was possible to write a whole word without lifting the pen. Without the use of ligatures or connecting strokes, as seen for instance in script or more formal writing, a large number of pen lifts must interfere with continuity with a resultant loss of fluency and speed – one criticism being that in achieving this end too much has been sacrificed'. If Copperplate was not advocated then what was recommended and what else ought schools to consider? The report praised Marion Richardson saying: 'Her close study of the natural processes by which a child develops and the adaptations of her methods in harmony with this development ensured a ready acceptance of her teaching. She dispensed with the ugly and confusing loops which had festooned so many of the copperplate letters and she advocated a beginning with chalk and crayons and the final use of the right-shaped pens'. This term *right-shaped*, which must mean the broad-edged nib, revealed the real preferences of this panel. Of the twenty one recommended books, all except Marion Richardson's own relate to italic handwriting.

W F Houghton, the education officer at County Hall, along with the inspectorate, acknowledged Alfred Fairbank, both as a historian and teacher, as having made many contributions of great importance to their study: 'Invited by an education authority to design an alphabet for schools based on principles governing the best historic examples and simple enough to be acceptable to them, he produced an excellent series of writing cards and a manual of handwriting' – presumably they were referring to the cards Fairbank's initially produced for Barking schools (see page 72).

A fair comparison of the two styles was made: 'A study of Marion Richardson's and Fairbank's approach will show that there is much which is fundamental and common to both. The basic rhythm of the latter is more sloping and compressed and it is possible that this may lead towards writing which can be written at greater speed. An examination of the two styles will show that the shapes of Miss Richardson's letters were influenced by her desire to relate her writing to pattern and the need she felt to limit the number of penlifts in the writing of a word'. The report concluded that: 'Either approach could well be adopted and any conflict arising at a later date by reason of a pupil's meeting the other style could easily be resolved'.

The only practical issues concerning infants mentioned in this report turned out not to have been necessarily in children's best interest. The first controversial statement was that 'for the younger child especially it is important that a thick stubby penholder should be used instead of the thin type found in schools'. It must be questioned whether this was based on research or was just speculation. The statement, *'research has shown'*, all too often precedes the advising of the use of fat pencils for young children, even at the end of the century – yet no one has ever been able to trace such a research project. It seems likely that this much publicised document was the origin of the advice. Experienced teachers have long found this practice to be wrong, yet forty years on this repeated assertion resulted in some of the local authority stores who supply infant schools refusing to provide them with other than with fat pencils. Even today manufacturers still quote this 'research' as an excuse to manufacture only fat-barrelled modern pens for schools.

The second statement that 'as far as possible writing should be done on smooth unlined but not on glossy paper' has also had far-reaching repercussions. Lined paper quickly disappeared from infant schools and is only now beginning to reappear. Once again there appears to be no real research to justify such an inflexible pronouncement, one that has caused problems for many young writers in the intervening years.

Suggestions for Primary Education
In 1959 HMSO produced *Primary Education*, a book subtitled 'Suggestions for the considerations of teachers and others concerned with the work of Primary Schools'. It begins by mentioning that the last *Handbook of Suggestions for Teachers and Others* (see page 93) was published twenty two years ago (and republished in 1944). It recognised the disruption to education caused by the war, and the consequent halt in any material advance, 'although this period had stimulated rather than quelled constructive thought'. It was noted that the Education Act of 1944 had made that earlier handbook obsolete 'by abolishing the term Public Elementary Schools and establishing, by statute, Primary Education as a recognisable stage in the national system of education'.

Handwriting was given more prominence in 1959. The section on the subject covered a brief history of handwriting, twentieth century developments, including a fairly detailed description of the work of Marion Richardson, and then it dealt with what it termed 'The Present Position': 'It is a heartening thought that, in an age when so little of craftsmanship is expected of anyone and when it is easy to say that few people care about

quality and standards of work done by hand, very many – both in schools and outside – are deeply concerned to give handwriting once more its proper dignity as the most universal of all crafts'. This report takes quite a different attitude to teaching handwriting. It is based on the premise that teachers have the ability to write what they term, 'a traditional hand' well. It continues: 'If the first writing that the children see is the simplest version of the traditional running hand then they straightway begin to copy it. Provided the teacher has herself mastered the craft she should not find it difficult to present to them a 'standard' form of it, that is to say, one without her own idiosyncrasies or deviations from the norm. Knowing that children tend to exaggerate such differences she is therefore careful to let them see only the clear elemental shapes, each showing its essential features that distinguish it from every other'. Under the heading 'Handwriting as a rhythmical movement', advice still intended for the infants school continued: 'When she writes for children to see she will usually write a fully cursive hand, where many of the letters are naturally linked. When copying what she writes not all children at first use these ligatures; some may draw the letters separately, packing them closely into words. It has surprised many teachers to find that young children are quicker to come to a completely running hand than was formerly thought'.

There is no mention here of any particular model, nor were any copy book techniques suggested. This may be because at that time teaching was still firmly in the hands of teachers who were still expected to have had a good foundation in the subject of handwriting during their own childhood. They would probably have a good personal script and were usually taught blackboard skills during their training. This kind of directive gave teachers confidence in their own skills and such expectation was likely to be justified at that time. Up until the 1970s one or more such experienced teachers could be found in most primary schools, probably nearing retirement, yet keeping an eye on handwriting throughout the school.

This book also gives interesting practical advice on teaching techniques, starting out with: 'As the business of recording in writing becomes more necessary and absorbing to a child he may need more technical help from his teacher. For example, if he grips his writing tool or holds it awkwardly, he may be prevented from achieving an easy flow in what he tries to write. ... Always a child must be allowed the time to practise at his own pace until he himself sees that he is making good progress. ... There is every reason for ensuring that whatever notices, labels, titles or other pieces of handwriting children see in the infant school should be as good of their

kind as the teacher can make them and that they should be done in a fully mature hand' and much more. No didactic rules here, only common-sense advice which would prompt teachers to observe the maturing writing and be on the look out for possible problems.

The relationship between reading and writing

It is interesting to note other differences in attitudes half a century ago. These might be termed opinion, but just as easily they could be explained by the relative experience of teachers and maybe their pupils as well. Take the subject of lines. Today we might argue with the advice that was proffered. Perhaps in the informed and more disciplined classroom of that earlier age, the thought that lines were unnecessary at any time for young children might have been valid. It is interesting to read the optimistic statement that: 'The experience of those teachers who have given consideration to such matters with children in infant schools undoubtedly shows that boys and girls readily accept and make their own the customary page arrangement that has come down to us through history. The formation of early habits of orderly planning of the page, varied to suit the work in hand and without the cramping restrictions of arbitrary lines, is the best possible foundation for a child's written work'.

On the subject of the relationship between reading and writing, it was reported in *Primary Education* that children find little difficulties interpreting the different typefaces used in their reading matter: 'If the teacher writes a traditional hand her writing will not be unlike the sloping variety, and so will their own. They may have heard some teachers to call the handwriting *writing* and to call the upright form *printing* and no one will say that they are very far wrong in doing so. Be that as it may, experience shows that any fears the teacher may have that the children's ability to read the printed word might be hindered because they do not *print* but *write* are groundless'.

The HMIs (Her Majesties Inspectors) who contributed to this volume show how broad an understanding of the subject they had, and how far thinking had progressed since pre-war days. A considerable amount of space has been given to the advice offered in this book, but even so, much of the detail has had to be omitted. The following chapters of this book, which chronicle great changes in the teaching of handwriting, show how little heed was paid to much of this advice in the following years.

Nearly half a century after the publication of this report, teachers themselves are less likely to have a clear, consistent handwriting, whether

ROBIN TANNER AND LETTERING FOR CHILDREN

abcdef
ghijkln

An alphabet by Robin Tanner and a page from his book, 'Lettering for Children'.

B stands for
birthday –
cake, pretty
and bright
When tea-time
comes the candles
will light.

C stands for
chocolates
bought at
the shop,
With hundreds
and thousands
sprinkled on top.

traditional or not. Many of them, particularly in the 1970s and 1980s, were taught little at school, so have not acquired an good grounding in the subject. There has been little taught to teachers during their training, leaving them without such skills as a blackboard hand. Then there is the difficulty in adapting to the various models that are used in different schools. Through no fault of their own, teachers are ill-equipped to give the next generation the start that they deserve.

A widening view of handwriting as a craft

Before investigating the rise of italic as a model for children, and the controversies that arose as its proponents tried to devalue any other forms of writing, the more rational attitudes that were striving to give handwriting and lettering more prominence as a craft deserve a mention. Robin Tanner, in his introduction to *Lettering for Children*, written in 1944, talked about the position of lettering in schools and the need for a wider outlook, saying amongst other things how beneficial it would be for every child to have control of two forms of writing: a cursive hand based on traditional writing for general use, and a parallel formal book hand in which both capitals and lower-case letters are more finely finished.

According to Prue Wallis Myers, whose 1983 article *Handwriting in English Education* is a valuable source in itself, and was herself an HMI, the handwriting entry in the volume *Primary Education* was contributed by Robin Tanner. Tanner was both an educationist and a craftsman. He was a teacher who was appointed to the inspectorate, where his influence soon began to be felt. His enthusiasm for both lettering and handwriting was coupled with a belief in their value in education. In the section of *Primary Education* given over to the Junior school, Tanner elaborated on his ideas for encouraging excellence in handwriting, pressing for what he terms 'first rate models' to be on display. He was not specifying any particular model, still noting that teachers' handwriting would be the greatest influence on pupils, whether in their books or on the 'wall board'. He added: 'The more the teacher is able to broaden the children's view by surrounding them with sound historical and contemporary hands the more likely are they to grow in sensitivity'. One suggestion that he made was to take rubbings of brasses and slate or stone inscriptions in churches. He was restrained and practical in his suggestions for tools and teaching techniques, not rushing into the imposition of a broad-edged nib, as so many others were soon to do in the pursuit of italic handwriting.

In *Lettering for Children* Tanner set out his views on the value of teaching

A page from an alphabet book of flowers, with pen drawings and stick printed borders. Lettered and decorated by a child of 14. From Robin Tanner's 'Lettering for Children'.

lettering and writing: 'If regarded as an inherent part not only of teaching but of general education, they can both provide a rich craft in themselves and form a cultural background of great significance in modern life'.

A survey of adult handwriting

In 1958 the state of adult handwriting in the country was recorded in a survey carried out by Reginald Piggott. It was 'a culmination of many years of research and experiment'. He advertised in national newspapers for samples of handwriting and was overwhelmed by 25000 in eight weeks. This method of collection might have had some effect on his findings, as only those with an interest in the subject and the motivation and time to answer this request would have participated. None the less, this national survey presents a fascinating study of the handwriting of the time. Overall he found, in terms of style of handwriting in use: 2.1% wrote Copperplate, 49.1% wrote Civil Service, 8.8% wrote italic, 30.2% wrote a semi-joined hand and 9.2% used what he termed 'other hands' which he stated included Marion Richardson. Piggott classified his sample into twenty six groups according to their occupation, so it is possible to record the handwriting of teachers. He found no teachers writing Copperplate, 35.9% wrote Civil Service Longhand, 14.5% italic, 38.4% joined, semi-joined or non-cursive scripts, and 11.2% other hands.

Piggott did not survey children's handwriting, and, being a convert to italic, produced, in the second part of his book, his own model alphabet, saying: 'Full benefit (*of his own italic*) would only be felt, however, by complete co-operation between teachers and education authorities for there must be no great variation from school to school in either the model alphabet or in the method of writing it'. This italic model was used when in 1978 Piggott wrote *Handwriting a Workbook* jointly with John Bright.

The contrasting advice from above, allied to differences between the training of teachers and resources in schools, led to considerable variation. Ruth Fagg (see page 129) remembers teaching groups of over fifty in tiered LCC classrooms just after the war. The children had received scant education and there were few teaching aids – no copy books only the teacher and her personal handwriting on the blackboard, demonstrating from the front of the huge classes. At the other extreme, Wilfrid Blunt was beginning to teach the Chancery script, what he termed the Sweet Roman Hand, to boys at Eton. Meanwhile the framework for teaching letterforms was being dismantled. By 1948 lettering as a subject in art schools and teacher training colleges was being discontinued. It was considered to be repressive.

PIGGOTT'S GRAPH OF WRITERS' OCCUPATIONS AND STYLES

LIST OF GROUPS OF OCCUPATIONS AND KEY TO GRAPHS
(1) Architects, Draughtsmen, Industrial Designers, Surveyors, Cartographers, etc.
(2) Artists including Painters, Sculptors, Artist-Craftsmen, Commercial Artists and Designers of Fabrics, Footwear, Ceramics, etc.
(3) Authors, Editors, Publishers, Journalists, Translators, Playwrights, and Poets, etc.
(4) Booksellers, Librarians, Cataloguers, Archivists, Museum Assistants, Public Records, etc.
(5) All Civil Servants and Local Government Employees including Postal Workers and Gas and Electricity, Water and Coal Board Employees, etc.
(6) Clergy of all denominations.
(7) Clerks, Accountants, Bank Employees, Bookkeepers, Statisticians, Economists, etc.
(8) Company Directors (active or 'sleeping'), Bank Managers, Principals in Private Undertakings, etc.
(9) Doctors, Medical Students, Chemists, Dental Surgeons, Chiropodists, Nurses and Midwives, Psychiatrists, etc.
(10) Engineers of all trades, Carpenters and Joiners, etc.
(11) Entertainers. Radio, Television, Film and Theatre, Actors and Actresses, Musicians, etc.
(12) Farmers and Agricultural Workers, Horticulturists and Gardeners, etc.
(13) Housewives solely employed domestically including those with part-time non-remunerated occupations (committee work, etc.).
(14) Housewives engaged also in full or part-time paid occupations.
(15) Lawyers, Barristers, Justices, etc.
(16) Heavy Manual Workers of all grades, Labourers, Dockers, Miners.
(17) Retailers Shopkeepers, Employees in the Distributive Trades.
(18) Scientists, Research Workers etc.
(19) Secretaries and Shorthand Typists.
(20) H.M. Services, all ranks, male and female.
(21) Students (full-time Art, Technical Training College and University Students not including Medical Students).
(22) Teachers (A) Nursery, Preparatory, Primary, Secondary, Grammar and Public School.
(23) Teachers (B) University Professors/Lecturers, Technical and Art School and FIE Teachers, Trades and Crafts Teachers at Local Institutes, Private Music, Speech, Drama and Ballet Teachers, etc.
(24) Transport Workers, Railway Workers, Delivery and Long

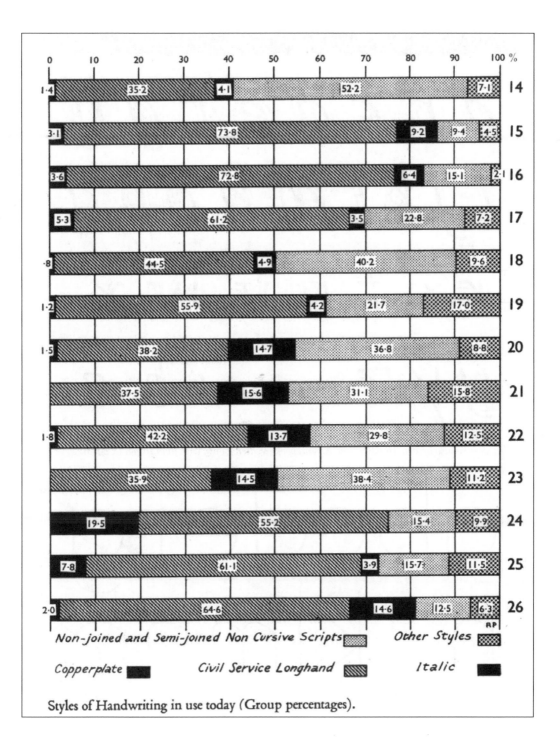

Styles of Handwriting in use today (Group percentages).

REGINALD PIGGOTT'S MODELS

a b c d e f g h
i j k l m n o p q
r s t u v w x
y y z d b e

Italic and print script from Reginald Piggott's 1957, 'Handwriting, A National Survey'. The italic model was also used in 'Handwriting, A Workbook' written jointly with John Bright in 1976.

a b c d e f g
h i j k l m n o

TEACHERS' HANDWRITING THROUGHOUT THE CENTURY

ADMISSION No.	DATE OF ADMISSION.			DATE OF RE-ADMISSION.			DATE OF BIRTH.			SURNAMES.	CHRISTIAN NAMES.		WHAT, IF ANY CLAIM TO EXEMPTION RE MADE?
	Day.	Month.	Year.	Day.	Month.	Year.	Day.	Month.	Year.		CHILD'S.	PARENT'S.	
672	7	5	1900				20	10	87	Crisford	Gilbert		
673	1	6	1900	24	6	07	26	3	93	Kipps	George	John T.	
674	1	6	1900				27	7	93	Smith	Harry	Albert W.	
675	1	6	1900					11	93				

1900

New Testament	x	x				very good	
English Literature ...						very good indeed	
Grammar ...	4	4				good.	
Composition ...	7	7	d			Expresses herself very well	
Reading ...	17	17	d			fluent. must not clip words	
Recitation ...	3	3	p			Rather monotonous	

1914

Rosemary Waley. Prize. Dec. 17. 1937.

1937

Of the examples seem to be
the same but I have not

1950

B. I find your writing rather
difficult to read.

1970

No resources sonally int siple of 4
all brought t a large pr chers, our
we got from t and craft far more
which were i would enj riendly ta
to bringing being situa

Trainee teachers in the 1990s.

DIFFERING REPRESENTATIONS OF PRINT SCRIPT

From the UNESCO report 'The Teaching of Reading and Writing' by W S Gray.

Bob blows up a balloon

From ESA's 'My First Handwriting Book' by Paull and Haskell, and designed by Van der Meer.

abcdefghijklmn opq

Alfred Fairbank's letters from Ginn's 'Beacon Writing Book One'.

I will take her out.

From Rowlandson's 'Second Steps Script Writing Book' from Philograph Publications.

a b c d e f g h i j k l m n
o p q r s t u v w x y z

From the Platignum booklet 'An Introduction to Firsthand Writing' by Tom Barnard.

From Longman's 'Basic Handwriting Book 2', by Margaret Hooton.

CHAPTER 7
Stylistic issues after 1950

THROUGHOUT THE 1950s, a flood of new handwriting models came on the market. How quickly these were bought and assimilated by schools, in a period of relative austerity, it is difficult to assess. Piggott's survey showed that many teachers themselves still wrote Civil Service hand, and doubtless many children were still taught this style, particularly in the more traditional schools of Scotland and Northern Ireland. Longman's *Cursive Copybooks* show that there was still a demand for Copperplate-based models in 1954.

By now many schools had adopted a print script model, and teachers were beginning to find how easy it was to teach. At the same time Marion Richardson's copy books were widely used to teach a simplified joined hand for young children. They provided a compromise between the idea of separate print script letters and that of joining complex letters from an early age. Italic handwriting was also beginning to gain a certain popularity. No study was undertaken as to the actual usage of the different schemes or styles of handwriting in schools. It is likely that there were considerable variations nationally, with the north keeping to the old traditions longer than the south.

There were proponents for all these styles, and considerable arguments raged in the educational and letterform press. Already, it seemed, the lines were being drawn on stylistic grounds alone. Practical instructions on how to write were given less and less prominence.

The argument for print script

By the middle of the century print script was widely used in schools. The concept that these simplified letters were easier and better for young children to write seemed firmly entrenched. William S Gray, an American educationist, compiled *The Teaching of Reading and Writing* in 1956 under the auspices of UNESCO. He gave unequivocal support to print script and recommended it for use worldwide stating: 'Because of its proved advantages, all countries which use Roman letters, but which have not yet adopted the use of script during the first two years, should seriously consider the wisdom of doing so'.

This advice might well have been appropriate for Gray's own country, and for others who were still teaching different forms of Copperplate to infants, but it was unnecessary in Great Britain. He seemed to assume that all countries at that time taught the same initial model. In doing so he ignored both italic and the simplified Marion Richardson semi-cursive that had been used for over twenty years in British schools. The backing of such an influential institution as UNESCO ensured that this study was widely quoted. Peter Smith, for example, in *Developing Handwriting*, published in 1977, supported Gray and added: 'The main advantages of print script over cursive styles are generally held to be:

1 The letters have simple forms
2 The alphabet is the same as the children meet in reading and so confusion is avoided
3 Print script is similar to drawing
4 No strokes are needed for joining
5 Children using print-script are able to express their ideas on paper and more quickly
6 There are fewer failures
7 Print script allows comparison with printed letters
8 There is less eye strain than with cursive letters
9 The rounded shapes of letters are more suited to the muscular and motor movements of small children than the elliptical ones associated with most joined styles'.

Smith recommended the use of print script until the age of seven. He claimed that at the time of transition to joined up writing the child would need only to add ligatures and alter from a round to an elliptical shape and from upright to slanting strokes. Only many years later was this shown not to be so simple. Print script – or manuscript as it is called in America – is indeed easy to teach, but it trains the child's hand in an abrupt movement, with all the pressure on the baseline. This must all be retrained before attaining a fluent joined hand.

The arguments against print script

The arguments against print script began almost as soon as the new models appeared, and have raged for over fifty years. In fairness it should be recognised that the development of simplified letters was a reaction to the complex letterforms being taught to young children at the turn of the century. Handwritten letters then bore little resemblance to printed ones. Decisions must also have been coloured by the time it took for infants to learn an adequate Civil Service hand at the expense of more creative activities in the classroom. Usually print script was intended as an initial alphabet only, with the writer progressing to a joined hand later on. A few people implied that joins should never be taught, and separate letters were adequate for life, without considering the implications of this new and fashionable style.

It takes a generation at least to discover the effects of handwriting reform. The following critiques were written as the consequences of print script became clearer. Tom Gourdie, whose interests were in calligraphy and italic handwriting, commented in 1981 that: 'Indifferent or even bad writing systems, mostly print script based, now proliferate so children naturally flounder when trying to write. It is only in this century that unnatural styles have been created, largely by educationists who were obviously unaware of the dangers of such interference since children exposed to them are seriously hindered from developing a swift legible hand'.

In 1976 ATypI (Association Typographique Internationale) held a working seminar on the teaching of letterforms. Nicolete Gray, the letterer and scholar, wrote in the report on the meeting: 'We are all, I think, entirely agreed that print script is unnecessary and pernicious. Convincing teachers on this point is a major task, at least in English speaking countries. This involves also the connection between reading and writing. Can we demonstrate that the advantage of writing the same forms of letters as those which are read is sufficient to compensate for having to relearn how to write at seven or eight, and for the bad handwriting that print script seems to produce.'

There were also different views of Marion Richardson's scheme. In 1952 in the journal *Athene*, Marion Duffield, a teacher, wrote: 'There is nothing to undo. The natural movements are all there, to be pleasantly guided by the delightful practice of the writing patterns. As the power to coordinate hand and eye develops with the child's age, the first steps to easy swift cursive writing are accomlished in the happiest possible way'. Whereas John Dumpleton, who preferred italic, saw the model's failings as: 'Inadequate aesthetic quality, not designed to stand the stress of speed, unrelated to any tradition and insufficiently identifiable with the printed roman letters'.

THE RESULTS OF PRINT SCRIPT

Children who are adept at print script are as disadvantaged as those who write it badly. Their bodies get used to the movement of abrupt letters, with maximum pressure at the baseline. It is difficult to ease this pressure at the same time changing direction in order to join up. They are reluctant to try joining which they see as disrupting the neatness of their writing, so the habit gets more entrenched.

This concept of neatness, whether the fault of the individual or the philosophy of the school, can be taken to extremes. Pupils who should have been joining long ago still cling to print. The over-rounded characters of teenage print results in neat, but sometimes unusual, not very legible forms.

Those who have not learned an adequate joined script in junior school often revert to print at times of tension later on or when their cursive becomes illegible at speed. While there is nothing intrinsically wrong with an adult using separate letters, it can send out certain messages about the writer's maturity. Research comparing the speed of competent separate letters with cursive is inconclusive, but it is likely that the constant repositioning and pressures at speed will be a strain on the wrist and eventually cause pain to the writer.

PRINT SCRIPT PROBLEMS

Monday January

Children who are allowed to print visual approximation of letters without learning their correct movement, like the seven year olds above, will have increasing difficulty altering them once automated. The straight letters do little to teach spacing by clumping letters together into words.

My Daddy is a painter and he did paint my h

I signal to his hon
ikard to the edge of
raft and peered dow

If older children try to develop a joined writing for themselves from a base of poorly formed and spaced print script, the result is often unsatisfactory. This is why an integral exit stroke on the first letters that children learn is so vital, and one of the reasons print script has fallen out of favour, despite the fact that many still perceive it as easy to teach.

a young man find out about murder

and thus can i take up

Incorrectly formed letters are not easily altered and go on to plague older pupils and even those at university, as shown above. Missing strokes and unconventional joins add to the tension of those who know that their handwriting is unsatisfactory, and make it difficult for the reader to decipher.

ITALIC MODELS

abcdefghijklmnopqrstuvwxyz.

From Percy Wood's 'Italic Handwriting for Schools', published by E J Arnold & Son Ltd.

abcdefghijklmnopqrstuvwxyz

From K C Yates-Smith's 'Italigraph Handwriting Copy Book 1', published by Philip and Tacey.

a b c d e f g h i j k l m n
o p q r s t u v w x y z z

From K C Yates-Smith's 'Italigraph Handwriting Copy Book 3', published by Philip and Tacey.

a b c d e f g h i j

From W Worthy's 'The Renaissance Italic Handwriting Books', published by Chatto & Windus.

a b c d e f g h i j k l m n o p

From Irene Wellington's 'Handwriting Copy-books', published by James Barrie.

a b c d e f g h i j k l m n o p q
r s t u v w x y z

From Patrick Barry's 'Handwriting Sheets', published by James Barrie.

abcddeefghijklmnopqrstuvwxyyz

From Wilfrid Blunt's 'Handwriting', published by James Barrie.

Italic models

Of the many new italic handwriting schemes, some were meant for young children, and were suitable for them if properly taught. Some, such as those of Patrick Barry, were meant for secondary schools, and others were decidedly more appropriate for adults. Teachers such as Yates-Smith wrote some schemes and calligraphers such as Irene Wellington also produced copy books (see opposite). One influential scheme was different and needs to be looked at in more detail.

Beacon Handwriting was published in 1957. The co-operation between Charlotte Stone, art lecturer at the Froebel Institute, and Alfred Fairbank, the calligrapher (see page 73), should have ensured that vital balance so important to a handwriting scheme. Stone told the Society for Italic Handwriting in 1967 that during her teaching experience she had employed what she termed 'the Marion Richardson style'. This appeared to be successful for some years. When, however, she came to train teachers she said that she had been disturbed to find that many of the students, whose writing she was trying to reform, had been taught the Marion Richardson style. She had come to the conclusion that this was not the right answer and had adopted italic as the most suitable model for general teaching. As she put it: 'The actual writing of the teacher was of paramount importance, therefore the teacher should be able to write properly'. As children might have to alter styles during their schooling, Stone thought the only remedy was a consistent policy for handwriting throughout the educational system. By this she meant, of course, introducing italic as a national model. In fairness to Marion Richardson, it must be stressed that if teachers had followed the complete course of *Writing and Writing Patterns* suggested by that great educationist (see page 77) instead of ignoring the suggestions for older pupils, mature writers should have finished up with an italic very similar to that of Fairbank's own.

Charlotte Stone's dislike of print script sometimes led her to exaggerate. In 1964 she wrote: 'If the individual letters are taught too soon, as in the print script method, not only is the child's natural rhythm destroyed but he is unable to see words and sentences as a whole'. It is difficult to see how the simplified italic, although there were fewer penlifts within the letters than in ball and stick writing, would make words and sentences any clearer as a pattern for infants. Stone's teachers' book for parts one and two of Beacon Handwriting concentrated on shape and form, providing imaginative examples of pre-writing scribbles alongside classical architecture. Her stated priority was: 'Harnessing the child's natural sense of rhythm to definite shapes and movements'. She offered no practical instructions on writing strategies.

BEACON HANDWRITING SCHEME

nnnnnnnnn
hhhhhhhhh

An exercise from Stone and Fairbank's 'Beacon Writing Book One', published by Ginn in 1957.

The sky all blue
And the air all mild
And the fields all sun
And the lanes half

From the 'First Supplement to Books One and Two.

un in um im nu mu ni mi
nun mum murmur rung
andy candy minute mind
tune time mute mine

An exercise from stage twelve in 'Beacon Handwriting Book Four' by Hooper and Fairbank.

Fairbank's contribution to Beacon Handwriting
Alfred Fairbank's reputation as one of the nation's leading scribes added weight to this whole project and his letterforms, rendered initially in Conte pencil, ensured the copy books a permanent place in the history of handwriting. The simplified italic forms mark a departure from his own previous models. The first two books were written in what Fairbank described as: 'An italic which has been modernised and adapted so that in its simplest form it is easier to teach and write than print-script'.

This departure, perhaps the result of the mid-century emphasis on the desirability of teaching simplified letterforms, has had unfortunate effects, both on those who were taught it, and the future of italic in Great Britain. The emphasis was on shape. The omission of exit strokes to allow forward movement between letters in the two original copy books meant that young children frequently had problems in altering movement and pressure to add an exit, and then join up to acquire a free flowing hand. It is reported that many years later, Fairbank himself suggested that this might have been a mistake – but the damage was done.

Stone explained in the teachers' book: 'We have not included serifs in books one and two as it is desired to make copies of the greatest simplicity for the early stages of writing. Before the small child is taught to use a pen the teacher may wish to make further progress towards that stage'. In a later (second) supplement to the Beacon books exit strokes were added to the letters in the same medium and scale suitable for infants. How widely this supplement was used is now conjecture. From contemporary examples, exits were seldom evident in the writing of young children, yet Fairbank himself had written of print script: 'The infant will have established a foundation of movement skills which now must change and that may not be easy for him'. Fairbank and Stone did not realise that the same would apply to simplified italic.

'Books three and four of the Beacon series are intended for beginners in the use of the italic cursive hand,' wrote Winifred Hooper, a primary school head teacher, who provided the text for these books. The letters now had integral exit strokes, but the scale of the models suggests that they would be unsuitable for children under the age of seven. How to produce thick and thin strokes with an italic nib takes up much of the teachers' book, along with details of the letters to be copied. No other help is offered concerning such important matters as penhold or paper position. Beacon Writing books five and six consisted of copy books written by Alfred Fairbank, and according to him: 'Are intended to give the practice that is essential for the development of the child's handwriting when pen and ink are used'.

2 July 1957

Mr Paul Green-Armytage, Downside School

Dear Mr Green-Armytage

Thank you for a specimen of your hand, which I find attractive — which is one virtue and legible — which is another & superior virtue.

I hope you will add a third virtue in due time & after practice: speed.

Yours

Stanley Morison

In praise of italic

'Success in handwriting is closely related to the models that are taught. It so happens that a simple, elegant and practical model is readily available. This is italic script, evolved for the twentieth century use from the chancery hands of the fifteenth and sixteenth century, as seen in the manuals of writing masters, such as Tagliente, Vicentino (Arrigi), Palatino and Mercator'. So wrote Dr A S Osley in his book, *Scribes and Sources,* in 1980. These sentiments reflected the views of many artistic and literary figures who had been drawn to the beauty of the original manuscripts. Those involved in both teaching and promoting italic letterforms filled the decorative quarterly issues of the Journals of The Society for Italic Handwriting (founded in 1952) with a succession of articles. They set out to demonstrate how italic could transform children's handwriting. Books such Wilfrid Blunt's *Sweet Roman Hand* in 1952, or the volume produced by Blunt and Will Carter in 1954 were full of with examples of prominent exponents of the italic hand from writers, artists and many from the discipline of letterforms, as well as a selected few school children. Blunt was art master at Eton and Carter a typographer and letter cutter (see page 147). Their own expertise and enthusiasm was never in doubt. The problem was that other people might match their enthusiasm but lack their expertise.

Fast, and very fast, personal italic by Wilfrid Blunt.

THE ART SCHOOL,
HARROW SCHOOL,
HARROW-ON-THE-HILL.
BYRON 3022.

16 : July : 57

Dear Green-Armytage,

I write like this :- A B C D E E F G
H I J K L A I N O P Q R S
T U V W X Y & Z quite fast
with any sort of nib, even a ballpoint,
but you can see it's not really Italic
like yours.
Also :- abcdefghijklmnopqrstu
wvxy&z
Yours sincerely, Maurice
Percival

Above: Maurice Percival's relaxed italic written with a ballpoint pen, contrasts with J le F Dumpleton's more formal script. It is necessarily slower, in spite of his description of it as written at scribble pace. His teaching alphabet appears underneath. Both letters are from the collection of Paul Green-Armytage.

the virtue of italic is that it does not

degenerate into illegibility, even at a

scribble pace such as this.

abcdefghijklmnopqrstuvwxyz

Towards italic as a national model

Many powerful people backed the movement to have italic introduced as a national model. They included Alfred Fairbank, Reginald Piggott and Tom Gourdie. The Society for Italic Handwriting prepared a memorandum for the Plowden Committee whose report into the changing pattern of Primary Education was published in 1963. Ironically, there was not even a mention of handwriting as a subject in the index of that report. Another unsuccessful attempt was made to influence the Bullock report in 1975.

There are cogent arguments in favour of italic, other than its artistic appeal. Oval slanting letterforms are economical, especially when joined. However, they are the result of a particular way of using the pen, and specific hand movements. Such movement will be influenced by particular characteristics of the writers and the way they use their bodies. For those to whom this proportion and slant of letter come naturally, it is difficult to comprehend why all children should not be trained to write italic. Given enough time, with great stress being placed on details of the model, by trained teachers who should be competent and enthusiastic italic writers themselves, maybe this would succeed. However, the educational environment into which this model was launched was far from ideal.

The problems involved in teaching italic

What went on in many classrooms was far from what Fairbank and his followers envisaged. The curriculum was expanding, the emphasis was beginning to be on the creative use of writing rather than the skill element. Many teachers were themselves uncertain and unable to perceive or represent details of the letterforms, the subtleties of the upstroke in particular. They perceived and produced some of the letters as triangles, and their pupils tried to copy their teachers. The result was often a zig-zag of slow angular letters. The majority of examples produced, even in prize-winning schools, were nowhere near the standard of those used to promote italic as the ideal model for young children.

Some schools persevered and, in the intervening years, have established a tradition of italic. This has always been to the benefit of a proportion of their pupils who have acquired a valuable asset for life. However, a considerable proportion of every group has found it a grave disadvantage. They may have been chastised for their inability to reproduce the model, their confidence and even their examination prospects damaged because the proponents of italic failed to understand the realities, as well as the aesthetics, of the act of writing. italic, however, has worked particularly well when introduced voluntarily for

those attracted to the style in secondary schools. Walter Strachan showed how this succeeded through his work at Bishop's Stortford College.

There were other problems that those experts in the use of the broad-edged nib did not envisage. Some people insisted that the broad-edged pen was essential to italic writing, even for infants. There were specially angled nibs for unfortunate left-handers, many, though not all, of whom found italic an insuperable hurdle. This insistence of the purists on the use of the broad-edged nib as an everyday writing implement in the age where speed is such a priority, may have been one of the reasons for its abandonment by many education authorities in Great Britain.

When and where handwriting can be perceived as an art, then the broad-edged nib can be recommended. However, it needs a skilled hand to write at speed with such a pen. When it proves to be too difficult for the writer to negotiate the upstrokes or arches, then the speeding up of what might have been an attractive, juvenile calligraphic hand becomes an illegible zig-zag. We can no longer say, as Graily Hewitt did (see page 59), that fast handwriting should not be considered as handwriting at all. The realities of our educational system means that the better the students, the faster they need to write.

There were severe critics of both the tools and the forms of italic. Ruth Mock, in the prestigious *Dossier A-Z* published by ATypI (Association Typographique Internationale) in 1973 bravely struck out saying: 'It is strange that italic script has attracted so many fervent disciples in recent years. We are no longer dependent upon goose feathers, and contemporary italic script is as false as neo-Tudor architecture, and there is as little reason for its reproduction'.

Calligraphers are notoriously dogmatic when it comes to their own letterforms. The italic fraternity was constantly riven with dissension over relatively irrelevant details. The battles were sometimes fought out on the pages of the *Society for Italic Handwriting Journal*, sometimes in other publications or in public. These arguments, perhaps fuelled by the commercial value of their various published copy books, perhaps by sincere conviction, did not help the italic cause.

'Temperamental as prima donnas, conceited and humourless as operatic tenors, the English writing masters indulged ceaselessly in viterperation, wrangling, petty jealousies and the uncontrolled display of childish vanity.' So wrote Wilfrid Blunt in 1952. He was referring to sixteenth century writing masters. When the writings of the proponents of the different commercial models of the twentieth century are examined, there seems to be more than a passing resemblance to their predecessors.

ITALIC GOOD AND BAD

Two brothers, from a show school in the south of England which prided itself on its italic handwriting scheme, demonstrate how poor teaching can defeat the best of intentions. Left illustrates how a zig-zag movement was picked up from the start, while the right hand example could well be captioned 'torture by broad-edged nib'.

Even when supposedly well taught in primary school, italic was too often perceived as triangular. These scripts would deteriorate into an illegible zig-zag at speed.
Below: Walter Strachan taught italic at Bishop's Stortford College to older pupils who admired him and were motivated to learn. Their mature scripts show his success.

NELSON'S 'THE TEACHING OF HANDWRITING'

a b c d e f g h i j k
l m n o p q r s t u
v w x y z

The small letters from Nelson's 1964 'The Teaching of Handwriting Infant Teacher's Manual'

new limp nine menu keep

Mary had a little lamb

Above: Examples of joined letters from Nelson's 'The Teaching of Handwriting'. work books. Below: Instructions and exercises were given in the scheme for the development of an italic hand.

Practice in writing will help you to
become a better writer only if you keep
trying to improve letters and to write
more quickly, neatly and rhythmically.

CHAPTER 8
Initiatives in the 1960s

B Y 1960 CHILD-CENTRED LEARNING was fashionable and skill training began
to be eroded in the rush towards creativity. In 1968 Tom Barnard (see page
137) reported on: 'The current impetus for using discovery and environmental
methods of learning'. He continued: 'The changing pattern of priorities has
conditioned most teachers today to overlook the scribbles of pupils, when, out
of their struggles with experiences and words, they have been able to express
themselves in a commendable fashion; for it seems so petty to start
undermining the confidence of a child by quibbling about whether he has
crossed his 't's or dotted his 'i's. A page of good handwriting is pleasant to the
eye, but if it has nothing to say then it loses its point. But let us not forget that
the converse is true also, that a scribbled page loses its purpose if it cannot be
read'.

In 1960 Ruth Mock (see page 126) had put it rather more forcibly: 'Lack of
teaching is supported by lack of time, and the doctrine of free expression had
been taken to extremes upsetting the balance between a child's emotional
development, and that of his skills and intellect'.

Raymond Hawley's research, reported in 1968, revealed a little about what
was happening in the secondary schools. Starting in 1963 he had aimed at
objectively assessing the quality and speed of different styles of handwriting. He
described this as the difficult task of measuring speed and the almost impossible
one of measuring quality. His secondary school colleagues had decided that
italic writing was not fast enough for examination purposes – a point
strengthened by a report from GCE Boards. To compare the speeds likely to
result from different models, Hawley initially set about finding secondary
modern schools teaching one of what he termed the three main styles: Marion
Richardson, looped cursive and italic. He reported that temporarily his work
came to a halt as: 'For a time it appeared that there was not a single school in
the entire United Kingdom that did not either teach Marion Richardson or do
nothing in particular about handwriting'. He stated that whatever the criteria,
assessments of 'better or worse' handwriting remain subjective – and therefore
open to criticism. He found that bright classes write faster than duller ones,
that there were great differences exist between the performance of very similar
classes; attributing this to teacher differences, and that there was no statistical
correlation between writing ability and either age or intelligence.

When to teach and how to teach

When to teach handwriting, as well as how to teach and what kind of a model to use, came under scrutiny once more. Charlotte Stone suggested, in 1964, that writing should only come after children's interest had been roused by reading: 'When he has reached the stage in his reading, of beginning to break down sentences into words, to analyse letters and to be aware of spelling, then he will be interested in the actual formation of the letter shapes'. Stone was primarily interested in shape, and may well have been right, that it is not easy to interest children in the correct or conventional point of entry and direction of the strokes that make up our letters. Her views were in direct contrast to Montessori's theories (see page 84). Stone's timetable would inevitably mean that children would be experimenting with visual approximations of handwriting and automating an incorrect movement of letters that in turn would become increasingly difficult to alter. It was not only the co-author of the (by then) ten-year-old *Beacon* handwriting scheme who was thinking this way, so were those responsible for the Nelson *Infant Teacher's Manual* in 1962. In 1983 Prue Wallis Myers quoted them as saying: 'It is now commonly accepted that instruction in handwriting should begin with the writing of whole words, phrases or sentence, rather than letters or elements of them'. As Wallis Myers commented: 'But how can sentences be written until the child has learnt how to make letter shapes. It seems like starting back to front!' From the original Nelson manual it can be seen that the authors were themselves quoting from Gray's 1956 report on the teaching of handwriting.

The Nelson Handwriting Scheme

The Teaching of Handwriting was written jointly by Inglis, Gibson and McIntosh in 1962. This comprehensive scheme echoed many of the educational beliefs of the time. Stylistically, the six work books managed to incorporate most of the aspects of letterforms in favour – print script in the two infant books, letters with 'tails' and a simplified semi-joined script for primary, and a broad-edged italic alphabet in the last two books. Of these letterforms Inglis and Connell wrote in the *Infant Teacher's Manual*: 'It would be wrong to expect every child to write in an identical style. The letters illustrated in the schemes are the prototypes from which each child's individual style should develop and derive'. On writing readiness they wrote: 'There must be a preparatory period devoted to observation and assessment of each child, and to activities and instruction to promote readiness for writing. ... Perfection of letterforms must not be sought at the expense of fluency', and 'The mechanics of handwriting must receive adequate attention if optimum results are to be achieved'.

The Primary Teacher's Manual, much of it reportedly based on current research, did not recommend guide lines: 'They are a comfort to the teacher as they give a specious appearance of tidiness and quality to a pupil's handwriting. They are, however, an impediment to the development of the child's ability to write freely well-proportioned letters'. Pens and pencils were discussed in detail. Ballpoint pens had by then come into general use and provoked criticism: 'The writing produced by this type of pen is insipid and cannot be compared in quality or permanence with that produced by ink and a square-edged pen. Not only does the writing produced by a ball-point pen tend to be bad itself but also the use of of such a pen is detrimental to the development of good writing with an ordinary pen or pencil'.

Much emphasis is put on the details of joins with precise instructions as to which letters should join and which should be left unjoined.

as each hat tall

The Nelson scheme illustrated which letters should not join and why. The Primary Teacher's Manual said: 'Show the children why they should not attempt to join the Group 1 letters to a, c, d, g, o, q, and s which start at one o'clock position. Such joins would result in unsightly loops at the top of these letters as also would joins to the tops of ascenders such as b, d, f, h, k, l and t, which must not be attempted either'.

Away from the rather didactic instructions for letterforms, there is much of lasting interest in these teachers' manuals, for example: 'It will be found that in a normal class the writing speeds of children will vary very widely. It is common for the fastest writer to write at least three times as quickly as the slowest writer. For this reason it is difficult to fix writing speed norms for children of a given age. The speed at which a child writes will depend not only on his neuro-muscular development but also on his writing techniques and style of letters, on the nature of his previous training in writing, on the amount of practice he has been given in writing speedily and rhythmically and on the encouragement he has been given to take pride and pleasure in writing quickly and well'. The authors recommended regular speed tests in the classroom and informally at home.

Schemes of work applied to each work book, together with summaries and checklists, making *The Teaching of Handwriting* a useful guide for the classroom teacher. With updates in 1984 (Smith and Inglis), 1993 (Smith), and 1997 (Fidge and Smith) this popular scheme, now usually referred to as *Nelson Handwriting*, (see page 148) is still widely in use at the end of the century.

Ruth Mock

Despite increasing apathy in schools, a few individuals fought for the skill of writing, and what they considered children's best interest. Two exceptional, but relatively unsung figures, Ruth Mock and Ruth Fagg (see page 129), worked in the field in their different ways.

Ruth Mock's background was similar to that of Marion Richardson. She was an art adviser and teacher of great imagination. Her work was many years in advance of her time and her contribution to handwriting, for those open minded enough to appreciate her forthright views, should have been a blueprint for the rest of the century. Ruth Mock first made her views clear in 1955 in her book *The Principles of Art Teaching.* She said: 'Handwriting is determined by the tools available and by the sensitivity of the individual handling them. ... It is comparatively easy to impose upon children or adults a trick of writing which is sure to produce a certain conventional form, flattering to the instigator. But it is bad as well as short-sighted teaching to urge antique tools and forms upon children, who at home and in their jobs, will use the pen of their own time, and will dismiss with a shrug the quaint skill acquired at school. Whether we like it or not the fountain and ball-point pen are the tools of today, and we should earnestly set about the task of teaching children to use them in the formation of legible well formed handwriting. There is no short cut or substitute for honest teaching. There are several constructive methods of teaching handwriting, and whichever is adopted there must be allowance and respect for the personality of the writer. A style so formalised that it tells more of the teacher than of the writer is a sorry means of communication, however crafty it may appear on the page'.

Twentieth Century Handwriting was written jointly with V E C Gordon and published in 1960. They defined handwriting as: 'The result of mental and physical effort, the mental producing the thought to be recorded or communicated, and the physical controlling and directing the form and style of the writing. These two efforts are interrelated and interdependent, for every physical movement is the expression of thought or emotion, and is conditioned by mental achievement, states and tensions. Thus to instance everyday actions, our way of walking or of sitting down reveals to some extent our state of mind, physical condition and personality; and handwriting, which has the the additional characteristic of being permanently recorded, is in the same way a personal revelation, while, through the general style and the tool we use, is also an indication of the age in which we live'.

The two authors felt that: 'The recent revival of interest in the subject has been more concerned with results than with the fundamental problems of

teaching, and with so much thought being given to the question of how to make children reproduce one particular style, there is a need for re-emphasising the simple, yet all-important, considerations of posture, the use of tools, exercises, and the merits of different alphabets.

Gordon and Mock believed that the secondary school pupils still had need of guidance: 'They have to work faster and are losing their enthusiasm for basic skills, and their wider interests make them intolerant of the simple, yet essential, exercises that are needed for the development of their as yet immature handwriting. At the same time their emotional development is often reflected in irregular forms in the conscious adoption of an extravagant style. Far from being left to do what they please with their handwriting, this is the time when, as in every part of their education and life, children need as much wise help and teaching as we can give them'. Of modern pens they wrote: 'Children should be encouraged to use as many different nibs and pens as possible, and they should be encouraged to discover their potentialities so that they realise which is most suited to their own style and purpose. ... To force all children to write with a certain nib is bound to irritate and discourage many, and can only result in senseless standardisation'.

ABCDEFGHIJKLMNOPQRSTUVWXYZ
abcdefghijklmnopqrstuvwxyz

Print script and cursive alphabets from Gordon and Mock's 'Twentieth Century Handwriting' in 1960.

ABCDEFGHIJKLMNOPQRSTUVWXYZ
abcdefghijklmnopqrstuvwxyz
abcdefghijklmnopqrstuvwxyz

The authors reviewed the different handwriting styles in use. It was only italic that felt the full brunt of their disapproval. 'Many people find it tiresomely mannered and, with its sharp angles, flattened curves and strong variations in the thickness of the strokes. Beauty is dazzling and difficult to read. The eye cannot easily take in a whole line, or even a phrase; it must move abruptly from one word to another. Beauty is a matter of personal preference. If some adults find italic script beautiful, there is no reason why they should not adopt it, but it is intolerable when personal taste dictates teaching methods and anticipates results'.

RUTH FAGG'S 'EVERYDAY HANDWRITING'

uuuuuuuuuuuuuuuuuuuuuuuuuu

i u t l u j y

mmmmmmmmmmmmmmmmmmm

n m r h k b p

vvvvvvvvvvvvvvvvvvvvvvvv

v w x z

ccccccccccccccccccc

c a o d g q

eeeeeeeeeeeeeeeeeee

e e f s f s e e

cicicicicicicicicicicicic

Ruth Fagg

Ruth Fagg gained her teaching experience in the deprived inner London classrooms, during and just after the war. Her first effort at producing a handwriting scheme took place when she was working in the gentler atmosphere of a school in the west of England. She had searched for a suitable commercial scheme, feeling that Marion Richardson's letterforms did not always develop well into a mature hand. She can still remember being dissatisfied with the selection on display at Foyles Bookshop and her mother telling her that she could do better than any of them – and to get on with it. She used handwritten advertisements from newspapers to analyse and criticise the letterforms that had developed from the models of the past decades. She took her ideas with her when she moved to Farrington's school in 1957. At first her handwriting project was directed at older junior school children. The younger children were being taught by someone who still believed in Copperplate. It was the young children themselves who saw the simplified letters on the school walls and demanded to learn them.

Ruth Fagg's work came to the attention of James Pitman. He considered it for publication, but later turned it down with the criticism that: 'It was obviously the work of a teacher'. This remark says much for the entrenched position of the calligraphic lobby, most of whom were not teachers. It was finally taken up by The University of London Press, soon to become Hodder and Stoughton. At first they had asked her to revise the Marion Richardson copy books. Ruth Fagg felt that Richardson's letters had too much emphasis on the baseline. While keeping to many of the same principles, she reduced the roundness of the exit strokes in the patterns and still more in the exits strokes of the letters. She said that she always looked at writing in the same category as dancing, as movement. Another of her comments was: 'A three year old will scribble fast and the child should never lose this faculty for speed'.

Everyday Handwriting was first published in 1962 and remained in print for over thirty years. The original project was, according to the author, vetted by Dr Hay, at that time Education Officer for the London County Council. There were five work books and a teacher's book that describes the reasoning behind this scheme. Letters in the first copy book had, as it pointed out, no serifs. Only in book two did the exit strokes appear. When new editions were produced, after twenty years, in 1982, exit strokes appeared on all letters from the beginning. As Ruth Fagg said, it was only in the 1990s that the publishers allowed completely new material to be introduced into a modified set of copy books, *Handwriting Practice*, written for the more general market. The restraints put on alterations by publishers, presumably for economic reasons,

can be infuriating to authors wanting to update their work. The pressure put on them to go against their better judgement in order to conform with perceived market forces, such as using print script rather than letters with exits from the start, may ensure wider sales but holds up progress.

Ruth Fagg frequently contributed to the educational press, with the emphasis on help for left handers, and the practical issues involved in the task of writing. Her book on helping left handers was published in 1990.

Illustration of writing posture and imaginative presentation of letter families from 'Handwriting Practice'. When these books were published, in 1992, Ruth Fagg was finally given more freedom by her publishers, Hodder and Stoughton, to develop her child-orientated material.

Give them names to match.

queen

It seems that Ruth Fagg's work hardly came to the attention of the italic handwriting enthusiasts, although, in his research (see page 123), Hawley remarked that the pupils he tested in a school teaching *Everyday Handwriting* approached their writing with a more practical attitude. (This was in comparison with a school using italic.) He reported: 'Speed came from practice and training rather than conscious effort and consequently, even when the children wrote quickly, there did not appear to be any danger that their hands would degenerate into a scribble. I have the feeling that the *Everyday Handwriting* of school 15 might possibly be better able to stand up to the needs of daily life'.

In contrast, Ruth Mock's strongly held and authoritatively expressed views could not be ignored. She was convinced in later life, whether justified or not, that her own book was not reprinted as a direct consequence of pressure applied to her publisher by the Society for Italic Handwriting. Disillusioned by such attitudes, she abandoned her work on handwriting. Her books on the teaching of art remain as a testament of her commitment to children, and handwriting studies are the poorer for ignoring her well-informed, child-orientated views.

CHILDREN'S EXERCISES IN 'EVERYDAY HANDWRITING'

nanananananana

n no na nan

uououououououououououou

owowowowowowowowowowow

how, show, now, snow, cow,

rararararararararararararararararara

at, et, it, ot, ut, at, et, it, ot, ut, at, et, it

rat, rattle, rat, rattle, rat, rattle, rat, ratt

All night long when the wind is high,
The lightships moan and moan to the sky,

Above: Various examples of children's writing books from Ruth Fagg's own collection, showing how the exercises in 'Everyday Handwriting' were used. Below: Ruth Fagg's personal handwriting.

I meet a lot of grandparents
about the young. If I give or lend them
books they always remark on my effor

The initial teaching alphabet

In 1961 a radical experiment took place in many schools. The initial teaching alphabet was introduced. It sought to make learning to read simpler for young children. This was a culmination of a movement to reform orthography that had started in America in the middle of the last century. An early alphabet, titled phonotypy, was devised by Sir Isaac Pitman and A J Ellis. The initial teaching alphabet was evolved by Sir James Pitman from his grandfather's original designs. It aimed at helping the whole word approach to teaching reading by removing variations in the visual patterns of words. The phonic method was to be helped by the removal of inconsistencies between written symbols and the sound they represent. To limit problems for children transferring to traditional orthography, most of the added characters that represent digraphs etc resembled symbols of the traditional alphabet.

 This alphabet was also intended for use as a means of expression. Amid doubts about its difficulties both of formation and transfer, the i.t.a. written alphabet was introduced. The whole experiment was short lived. All the criticisms proved true. By the mid-1970s it had all but disappeared.

The initial teaching alphabet showing the recommended way of teaching children to form the characters, from 'The Initial Teaching Alphabet Explained and Illustrated', written by John Downing in 1964. It was categorically stated that i.t.a., also known as A.R. (Augmented Roman alphabet), was not aimed at spelling reform. It was designed with the specific purpose of helping children in the early stages of learning to read.

the iniſhial teeching alfabet

juen 23rd mie nues.
ie went tu the zw and ie sau
an elefant and a tieger and a
lieon and a seelieon and then ie
went tu macdonalds and ie had
a cheesberger and chips and me

These examples come from an isolated school in Essex where i.t.a. was still being used in 1980. With expert teaching, five year old children were writing long stories in i.t.a. yet transferring to traditional orthography all in their first year of schooling.

mie nuer.
ie went tu futbaull and ie
had a rest in a chaer
ie went out ov the gaet
and ie went and ie
went hoem and tu plae

GOURDIE AND ATKINSON'S 'I CAN WRITE' SCHEME

hkhkhkh tl tl tl tl tl tl

at school

feeding the hamster in the classroom

ijmnoprstuvwxyz

fmf·fmff zmz·zmz

It is necessary to understand that all the exercises which follow should be done with the whole hand. If the fingers flex, then a backhand slope will be encouraged. Down-strokes will automat.

Above: An illustration from stage 2 of the scheme 'I Can Write', showing separate letters, then letters with entry and exit strokes, and some joined sequences. Lastly, Tom Gourdie's own handwriting.

CHAPTER 9

From 1970 to the National Curriculum

THE PERIOD BETWEEN 1970 and 1988, when the National Curriculum was introduced, saw less emphasis put on the teaching the skill of handwriting and more on creative writing. This did not stop new copy books from appearing. Stylistically, those models of the 1970s could be classified as 'Basic Modern Hands'. The main proponents were Tom Barnard, Tom Gourdie and Christopher Jarman. Jarman describes a Basic Modern Hand as: 'The simplest form of alphabet which can be written without any extra loops, flourishes or conceits. It must be both legible and economical. The letter shapes need to be traditional rather than novel for legibility, and skeletal and speedy in order to be economical'. Although Jarman added that: 'It should be plain and unobtrusive in character, so that having been acquired by any individual as a basic hand, it may be developed in character and personality to suit the writer', all three of these authors' models have a distinct italic bias.

The work of Tom Gourdie

Tom Gourdie, a well respected calligrapher, produced a prodigious variety of books on handwriting. The 1968 *Ladybird Book of Handwriting* (also published as *Learnabout Handwriting*) was aimed as much at the home market as at schools. These small format booklets, according to their publisher, sold many thousands. In 1983, Ladybird reported sales of 54000 per annum to Frances Brown, a researcher. This might well have indicated the concern that many parents felt at the decline of the teaching of handwriting in primary school, though Brown chose to explain their popularity as the faith the public had in the wide range of children's books that made Ladybird a household name. The 1974 Macmillan scheme, *I Can Write*, followed. Written jointly with Delia Atkinson, it was described as: 'A comprehensive scheme of tracing cards, worksheets and copying booklets in five developmental stages'.

With handwritten instructions throughout in Gourdie's italic, the monoline letters were designed with freer arches than those of Fairbank but again the letters of the first alphabets finished abruptly on the baseline. Stage 1 and 2 books projected a clean, sharp, static image, indicative of the time. Once the characteristic entry and exit strokes were added at stage 3, a stylised monoline

TOM BARNARD'S CONTRIBUTION TO HANDWRITING

These letters have 'arms'. a short arm.

bdfhklbdfhkl `tt

Your letters will now look like this. Write over the letters

ARMS
BODY
LEGS

itl·nmrhbp·uy

coadgq·e·vwxk·fjs·z

Above: Letters from Books 1 and 2 of Barnard's 'Handwriting Activities'.

ʊ ʋ w f h k

a b c d e f g h i j k l m

n o p q r s t u v w x y z

Pamphlets for Platignum show Barnard's versatility. He could reproduce any model with elegance.

itl nmrhbpk uy cadgqoe vw fjs x z

itl|nmrhbpk|uy|cadgqoe e|vw vw|fjs|x|z

italic was presented. The spirit masters that accompanied this series remind us how lucky schools are, thirty years later, to have easy access to photocopiers and computer printouts.

Tom Gourdie also produced series of cards, copy books and booklets on handwriting for MacDougall, in 1981, A and C Black, Studio Vista, Pitman, Penguin, Taplinger (USA) and finally a short-lived project in the 1990s for Blackie. However, Gourdie faced a major problem in Great Britain. His strong views and insistence on strict adherence to the details of his model were at variance with the educational atmosphere of the day. This meant that he failed to gain the backing of many education authorities or classroom teachers. Brown noted, in 1983, that she found a certain negative reaction to Gourdie in her questionnaire to teachers. This she attributed to a reaction to the Simple Modern Hand. He was later to find more support for his schemes abroad, especially Australia (see page 198).

Gourdie's committment to calligraphic standards, based on a sound scribal training, should not be underrated but his views did not always transfer well to the classroom. He was convinced that the act of writing should be with the whole hand with no intervention from the fingers, saying: 'If the fingers flex, then a back hand slope will be encouraged'. Adherence to the slant of his model was considered vital, for instance, even more so than the comfort of left handers who might have problems with writing with a forward slant.

Unfortunately, those opposed to italic, and other who see their skill as representing stylistic elitism, still seem to view calligraphers with suspicion. This appears to be a particularly British attitude when compared with the co-operation to be found in some other countries, Germany for instance (see page 169), between educationists and those in the field of letterforms.

Tom Barnard

Tom Barnard also started with a traditional scribe's training, yet his work had altogether a different tone to it. His letterforms took on a gentler appearance. No less a committed calligrapher, with an enviably free-flowing personal italic hand, Barnard reached out to children with more child-orientated letters, and illustrations. Ward Lock's *Handwriting Activities Book* in 1979 and their *Old Fashioned Handwriting Book* in 1981 were again aimed at the popular market as much as for schools. Perhaps Barnard's main contribution to handwriting and education was through the Platignum handwriting sheets. These were beautifully produced, illustrating not only a modern monoline italic, but also the other main styles in use. These booklets were distributed free to schools and teachers' centres. In this way they reached a large proportion of schools

CHRISTOPHER JARMAN'S 'HAND WRITING SKILLS'

Stage One

a b c d e f g h i j k l m n
o p q r s t u v w x y z

Stage Two, hooks added prior to joining.

a b c d e f g h i j k l m n
o p q r s t u v w x y z

Stage Three, joined where appropriate only.

abcdefghijklmn
opqrstuvwxyz

Pattern	*Value of pattern*
mmmm	rnmhpbk
ccccc	coadgqe
uuuuu	iuylt
wwwww	vwx
ululul	iuyltad
mmmm	rnpmh
oooooooo	co oo oa og od
ililililil	ilumh

over a long period of time, and together with Barnard's extensive lecturing programme, his techniques, if not always the italic model, were a considerable influence on schools. His *Write Away* workbooks, published in 1989 for Philip and Tacey, remain popular at the end of the century.

Illustrations from Barnard's 'Write Away' workbooks, and his signature.

Christopher Jarman

Christopher Jarman came to handwriting from a background of primary teaching and advising. He had been interested in italic writing since his teens before applying his skill to his professional work. He reported that he had been driven to research the history of the teaching of handwriting in order to solve some of contemporary teaching problems. His first publication, *The Development of Handwriting Skills: A Resource Book for Teachers*, published in 1979, dealt with the history, practical issues involved in writing, and a comprehensive teaching method (later extended in his series of copy books), as well as providing some calligraphic fun. This lively book has stood the test of time and remains as popular and useful after more than twenty years. His five copy books accompanied by an activity book, first published by Blackwell in 1982, have been widely used in schools and were reissued in 1997 under the new title of *Jarman Handwriting*.

To put these new models into perspective in the environment of the early 1980s, we can only rely on Brown's 1983 survey for her PhD thesis. In reply to a questionnaire sent to 300 schools countrywide, of the 182 who answered: 46% used Nelson, 21% used Marion Richardson, 6% used Gourdie, 4H% various Barnard models, 4% Fagg, 1% Jarman, 1% traditional italic. Print script, looped cursive and 'others' making up the total. Knowing what was happening in many schools it might be suspected that the remaining hundred or so schools who failed to answer, taught nothing at all.

What was happening in the classroom

These commercial schemes did not necessarily reflect what was happening in the classroom, where attitudes seemed to have become polarised. At one extreme nothing at all was taught. It was considered repressive by many educationists to teach handwriting. The idea seemed to be that if children were allowed to play with letters in whatever way they wished, to communicate their creative ideas, then somehow they would learn to write by themselves. One London Borough when offered an inservice talk on the subject, in view of its children's obvious problems, replied that they did not want their children worried about handwriting. Bullock was to report in 1975 that 12% of six-year-old pupils spent no time on the teaching of handwriting and among nine-year-olds the figure was as high as 20%.

This attitude was fostered by such publications as Marie Clay's *What Did I Write* in 1975. Her text, accompanied by delightful illustrations, stated that: 'Young children produce mixtures of real letters, mock letters and innovations or inventions when their knowledge of print is still limited. With considerable flexibility they explore the limits of allowable variation in the alphabetic signs'. So far this would be perfectly acceptable when applied to pre-school children. But the statement 'Such flexibility *probably* leads to the discovery of more and more orthodox letters' might not be so well received today. Clay herself was concerned with the product of writing, rather than the process, but her idea of playing with letters was attractive to educationists just as the idea of emergent writing was coming into fashion.

At the other extreme, where handwriting was still strictly taught, adherence to a model was all important. There were still schools so committed to one or other style that any child entering from elsewhere would be forced to alter a perfectly adequate handwriting to conform to the prescribed model. State schools were just as likely to be guilty of this as private schools. Schools committed to italic handwriting, often successful in national handwriting competitions, did not allow pupils to write freely in their own way. All children were made to use broad-edged nibs however unsuitable for their real needs. Some of those schools who purported to teach Marion Richardson caused just as much damage by forcing all their children to copy their own representation of the model which was often perceived as round and upright, far from the original. Considerable hardship was experienced by those who were unable to attain an acceptable version of the school model. Many conventions had been relaxed. Handwriting was one of the last controls that teachers could have over pupils. Used repressively, there could be serious repercussions.

The imposition of a model in itself is not necessarily harmful, particularly

when only used for a short time and flexibly for those who cannot conform, for one reason or another. However, in the 1970s and 1980s the problem was the expectation that to copy a model was enough. Few teachers had the training to understand about the mechanics of writing. Many appeared not to comprehend the importance of the correct point of entry and direction of the strokes that make up the basic letters of the alphabet. Subjective judgements were passed on the degree of adherence to the model and conventional neatness. While head teachers might indicate that one scheme or another was in use, few copy books were in evidence in classrooms. Teachers then were dependent on their own perception of the supposed model. This often resembled their personal writing more than the intended letterforms.

There were exceptions, of course, where expectation and example, in other words, good teaching, succeeded where dependence on commercial schemes failed. Darrell's frequently quoted remark (from Fairbank 1932) sums it up nicely: 'Good copybooks provide good models but, with children, good models do not necessarily provide good writers – good teachers are the link'. Many schools in Scotland, Ireland, and the north of England, in particular, kept up a tradition of good handwriting. It was schools in the south of England and the ILEA (Inner London Education Authority) that seemed most affected by the progressive ideas that valued creativity above the skill of handwriting.

Teachers themselves cannot and should not be blamed for what happened. As Wallis Myers put it: 'With so many language needs to be met, there was little time to correct letter formation or spacing. Even the least successful examples might be displayed as a means of encouraging the individual child'. In other words, the expectation that children could write well was fast disappearing. Along with this came the idea that handwriting was difficult to teach and perhaps that eventually it was not worth wasting the time to try to teach it. All the while the traditional teaching skills were being forgotten.

Official guidance

Official guidance varied considerably. Wallis Myers pointed out that Plowden (in the 1963 report) had inferred that: 'Children learn the difficult process of writing by dictating to teachers, gradually copying their writing and then expanding a vocabulary and word building system, so as to be able to write for themselves. The method describing how children would initially be taught to make their letters is omitted'.

The Bullock report, *A Language for Life*, was the next to appear, in 1975. It concluded that: 'If a child is left to develop his handwriting without instruction he is unlikely to develop a running hand which is simultaneously

legible, fast-flowing, and individual and becomes effortless to produce. We therefore believe that the teacher should devote time to teaching it and giving the children ample practice. The first requirement is that the school should decide which style of handwriting is to be adopted and should as far as possible do so in consultation with the schools to which the children will pass'.

The report stated that: 'We do not propose to enter into the question of which model is best, for this must be a decision for the schools themselves. There are, however, certain basic principles which need to be taken into account when the matter is being discussed. One question on which opposing views are often expressed is that of the kind of handwriting with which children should begin in the infant school. Some teachers believe that a print-script should be used and that this should be as near in appearance as possible to the typeface of the child's first books, so that he will have fewer characters to learn. There is a certain economy in using the same alphabet for both reading and writing, but the opponents of print-script contend that it ignores a fundamental requirement of handwriting – a continuous linear, rhythmic movement'. They observed that: 'Many children do not find it easy to change letters to a cursive script, since there are no indications in the lower-case letters of print-script to suggest how they might eventually be joined'. At the same time they pointed out that a modified cursive or italic script makes possible a much smoother evolution to a running hand.

Bullock repeated the 1920 dictum that: 'The paper on which the children should write should always be unlined' and that: 'Crayons and pencils should be large enough in the barrel for small hands to manage them lightly and easily without strain'. Other points raised included: 'The correct hold should be encouraged from the outset and the child helped to achieve the right sitting position and relaxation of the muscles. He should also be shown how to form the letter shapes in the right way'. Bullock remarked that: 'For most children an upward stroke of the pencil seems to be the most natural movement'. It would be interesting to know on what basis this statement was made, although what followed is undoubtedly true: 'But if a child is allowed to form the habit of beginning letters from their bases the resulting will be a hampering movement which makes more difficult the development of a fast flowing running hand'.

The consequences of faulty techniques were described, the need for individual or group teaching was stressed, and suggestions were given for supporting for left handers. However, there was no obligation for teachers, or those who trained teachers, to heed such advice, and Bullock did little to halt the decline in the teaching of handwriting.

Intervention from other disciplines

The concern over handwriting was led by special needs departments who could not fail to notice that so many children were being referred to them for no other reason than they had never been taught to write. As a result those from other disciplines offered handwriting advice. In 1974, Margaret Clark, a psychologist, contributed *Teaching Left-handed Children*, a summary of research and teaching methods. Joan Cambridge, a graphologist and handwriting consultant, jointly with Elizabeth Anderson, wrote a book in 1979 aimed at helping Spina Bifida children. It provided a comprehensive method of teaching, with guidelines for teachers of nursery, infant and lower junior children providing a structured method equally suitable for able-bodied children. Reginald Phillips' expertise originally lay in pens. His books, *The Skills of Handwriting* published in 1976, and the earlier *Readable Handwriting*, provided detailed analyses of hand and letterforms, accompanied by suggestions for retraining.

An alphabet designed by Nicolete Gray in collaboration with Prue Wallis Myers, for use with modern pens.

Nicolete Gray, who specialised in the history and use of letterforms, worked with Prue Wallis Myers, by then an HMI, in the late 1970s. Their experimental alphabet was meant for use with modern monoline pens: 'We have chosen to emphasise the forms which show the characteristic differences best, thus stressing clarity, and the personality of the letter. Ascenders and descenders, by which the word patterns are largely distinguished, are emphatic, these also introduce movements which give the script character and rhythm'. On joining they wrote: 'The question of penlifts is fundamental because it conditions the rhythm of writing, and this conditions its speed and character. Writing the English language with all its manifold permutations of letter juxta-position is far too complicated to be able to lay down strict rules. We do not think all letters should join on both sides ... combinations of about three letters are probably the best for children'.

The National Writing Project and Emergent Writing

Other influences were helping to destroy confidence in the formal teaching of handwriting. Some of the trouble seems to stem from the fact that we use the same word for the act of writing and the creative aspect. The National Writing Project, under the auspices of the School Curriculum Development Committee, was launched in 1985. It was not the beginning, but the culmination of a move to put handwriting in the background. As far back as 1973 Joy Taylor had written of technical skill for those at school entry: 'The child has two requirements at this stage to learn how to control a pencil and to learn how to make the shape of the outlines with sufficient accuracy for them to be recognisable'. Only after more than 150 pages on gaining proficiency in reading and writing and such statements as: 'Once children can write with ease the teacher can begin training them to leaven quantity with quality', does handwriting get another mention. 'There is now a place for handwriting lessons – say about twenty minutes or so once a week'.

The planning brief for the National Writing Project stated: 'It is the aim of the National Writing Project to develop and extend, within the broader field of language skills, the competence of children and young adults to write for a range of purposes and a variety of audiences, in a manner that enhances their growth as individuals, their powers of self-expression, their skill as communicators and their facility as learners'. Nothing at all was mentioned then, or subsequently, in the newsletter that was produced quarterly in the following years, about how children were going to be able to record these creative ideas. This indicates how little concern there was for the skill of writing, yet if in one sense one cannot write, then in the other meaning of the word, creative writing is also not possible. It should be remembered that in the mid-1980s very few children would have had access to computers as an aid to producing written work.

Two of the children on the cover of the spring 1986 newsletter seemed to indicate concern over the act of writing and presentation of their work, rather than the content.

The work produced by the project ignored the fact that the inability to produce a satisfactory written trace would affect many young children's attitudes to written work in general. Such children risk becoming reluctant writers. This in turn can defeat the whole purpose of the freedom propounded by the enthusiasts of Emergent Writing, as the movement was often called.

Bridging the gap between skill and creativity – in Scotland.

The *Foundations of Writing*, published in 1986 by the Scottish Curriculum Development Service, was a report of a project on the teaching of writing at the early stages written jointly by William Jackson and Bill Michael. The first part was mainly concerned with the compositional aspects of writing, but considerable emphasis was put on drawing as a regular and serious activity. This was recommended as the best way of determining when infants are ready to learn how to form letters. The authors explained: 'Children have formed all the main shapes for our alphabet in their drawings and have shown that they can place shapes accurately within shapes and are therefore ready to begin handwriting, whereas these children, although able to show meaning in their drawings, have insufficient control to begin formal writing practice. If they are unable to control the placing of detail which is significant to them in their own drawings, they will certainly not be able to make accurately the arbitrary shapes of our alphabet'. Imaginative graphic strategies for assisting children to record their ideas and experiences are also shown in the book.

Jackson and Michael stated: 'All copying of letters should be banned until children learn to make them properly', and that writing should be taught at speed from the start. The second part of this unusual book dealt authoritatively with handwriting, which is described as: 'A subskill that cannot be taught effectively unless there is a policy that embraces the whole school'. The authors believed letters should be writing shapes and not printing shapes and that these forms should remain constant throughout primary school. Bill Michael incorporated into this report his 1978 *Letterforms Kit*, witha few modifications. The kit accompanied, by a teacher's handbook, is packed in a child-friendly, red bus-shaped box.

It was refreshing to read that: 'In many schools policy is dictated by a commercially purchased scheme, yet some of these schemes are ill-suited to produce the desired outcome, handwriting that is both fast and legible. In almost every case, commercial writing schemes bring a poor return for money and, in some cases, actually retard the children's progress'.

'Children are asked not to begin to form letters until their drawings show sufficient control.'

abcdefghijklmn
opqrstuvwxyz

'The ideal letter should look rather like this.' (Jackson and Michael 1986)

SOME MODELS OF THE 1990s

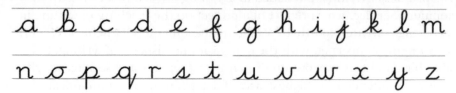

'The New Cursive Handwriting' from the Berol scheme devised by Paula Chapman.

abcdefghijklmnopqrstuvwxyz

From OUP's 'The Oxford Handwriting Practice' workbooks designed by Lida Kindersley.

From the 1995 edition of Charles Cripps' 'A Hand for Spelling', published by LDA.

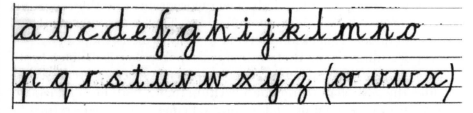

From Paula Morse's 'Kingston Handwriting Scheme', published by TRTS Publishing, Wrexham.

From 'The Christopher Jarman Handwriting Scheme', published by Stanley Thornes.

CHAPTER 10

The end of the century

FROM A SHORT PERSPECTIVE, it is difficult to judge which of the models in use at the end of the century are likely to remain influential. Readers are left to make their own judgement about the alphabets illustrated on the opposite page. The most widely used scheme at present is Nelson, followed perhaps by Jarman. The Nelson handwriting schemes have been modified several times since their inception in 1962. Finally, in 1997, they discarded their print script model for infants. The directives in the National Curriculum, aimed at earlier joining, started a rush by educational publishers for new teaching material. With few people left with a background in letterforms as well as in education, some compromises were inevitable. More informal letters, somewhat removed from the original concept of a model, may, in some circumstances, be easier for children and teachers alike to relate to – if so, whether more aesthetically beautiful models can be introduced later on is another issue to consider. Whether to use a single model or to give children a choice – or whether the child's own best effort should be used as a desk strip to encourage improvement – all these ideas remain for future discussion.

absolute freedom. In the same way that "absolute power corrupts absolutely"; so absolute freedom in letter design can be the greatest disadvantage to the designer.

Will Carter *Cambridge, England*

Will Carter's writing from A Typ I's 'Dossier A-Z'.

Some models seem to have arisen largely free (for better or worse) of classical preconceptions of letterforms. Others have tried to adapt models from abroad – not always successfully. Some would argue for a more knowledgeable approach. As Will Carter put it in 1973: 'The design of letterforms benefits from some sort of discipline, some sort of curb on absolute freedom. In the same way that absolute power corrupts absolutely, so absolute freedom in letter design can be the greatest disadvantage to the designer'. In this case, the reader, and those who have to copy some of the new models, also suffer.

The changing face of Nelson

the hill limit

Nelson letterforms 1962. *Nelson letterforms 1984.*

The Nelson handwriting schemes have dominated the market since they were first introduced in 1962. Smith and Inglis' *New Nelson*, in 1984, still recommended a print script model for infants. Peter Smith's *Cursive Copymasters*, produced in 1993 to accompany the *New Nelson*, provided a joining programme for Key Stage 1 pupils, noting that where children are taught print, the change to the joined style could be made at any time in Key Stage 1. The most recent edition, by Fidge and Smith in 1997, promotes letters with integral exit strokes from the start. In response to the aims of the statutory curriculum for handwriting: 'Children should be taught handwriting that culminates in a joined script that is a neat fluent legible style of writing'. This may be the best legacy of the National Curriculum: that print script is finally phased out of infant classes. Smith explained that the 1997 *Nelson Handwriting* includes provision for developing skills through a multitude of uses, giving spelling practice, help with note-taking and above all encouraging individuality, providing it has grown out of good roots.

A quick brown fox jumps over the lazy dog.

A quick brown fox jumps over the lazy dog.

Computer-generated letterforms from Nelson 1997.

The National Curriculum

Against a background of falling literacy standards, the National Curriculum discussion document was published in November 1988. It provided appropriate attainment targets, programmes of study and assessment arrangement for pupils at 5, 7, 11, 14 and 16 years old. From the beginning, the terminology used for handwriting led to misunderstandings and distorted the impact of the policy. The Key Stage 1 levels did much of the damage:

LEVEL 1 Begin to form letters but with little physical control over the size shape and/or orientation or lines of writing.

LEVEL 2 Produce properly orientated and mainly legible upper and lower case letters in one style (eg printed). Use upper and lower case letters consistently, (ie not randomly mixed within words). Use ascenders and descenders clearly.

LEVEL 3 Begin to produce a clear and legible cursive style.

LEVEL 4 Produce a more fluent cursive style in independent work.

LEVEL 5 Produce a legible handwriting in both printed and cursive styles.

Confusion arose over the use of *print* and *cursive* as two *styles* of writing, instead of the clear, familiar descriptors: separate and joined letters. If the intention was to promote early joining, then why use the word *print* at all? After protests, the word *cursive* was altered in 1989 to *joined-up*. Level 3 then read: 'Begin to produce clear and legible joined-up writing'. Levels 4 and 5 disappeared, but it has never been defined how joined joined-up writing was meant to be. Another vital omission has been that the importance of the conventional point of entry and direction of strokes of basic letters has never been mentioned. This should be the first teaching objective.

Undoubtedly the revised *English in the National Curriculum* succeeded in putting the teaching of handwriting back into every infant school. As consultant at the next stage in 1992, however, I can attest to the obstinacy of the committee who still refused to define their terms, understand that the correct movement of letters should be the first test, or consider that pen lifts were desirable during the writing of long words (reported in Sassoon 1993). Teachers got the impression, from an official booklet on how to mark the Statutory Achievement Tests (SATs), that a top mark could only be given when all letters were joined in every word.

Publishers, rushing to provide new material, did not wait for the final wording, and chose to put their own interpretation on the word *cursive*. This has led to over-emphasis on continuous joining. The intended non-statutory guidance never materialised, and modifications to the curriculum are still going on. In the test material produced in 1997 by The Schools Curriculum and Assessment Authority, content and handwriting were assessed together.

COMPUTER-GENERATED LETTERS

I couldn't face writi... / designed a typefac... / teachers can type i... / it through a joiner |

Sassoon Primary / handwriting. Exi... / make them more / letter spacing ca...

I have now spent m... / font which is really... / a font. It has to incl... / serve well enough fo... / who don't feel that th...

Computer-generated letters from Briem's Italiu Skrift, Sassoon Primary and Jarman's scheme.

Letter families in Sassoon Primary, a typeface allowing reproduction of both reading and handwriting material.

1 Trace over these in different colours.

2 Trace over these once.

ant ant ant

Sassoon Primary letters from 'Ginn's Handwriting' show how letters can join.

Circle the lower

a b c d e.

Name and over...

Different ways of illustrating the point of entry and direction of strokes. Left: From Collin's 'THRASS' and indented letters from 'Finger Phonics' published by Jolly Learning.

Handwriting and the computer

Two separate issues are involved here, the computer as an aid to teaching handwriting, and the balance between using handwriting and the keyboard.

Many efforts have been made to develop software for the teaching of handwriting. So far nothing has been produced that seems to be any better than using a pencil and paper, and being taught, in the early stages, by an experienced teacher. As technology improves there will doubtless be other possibilities, input by stylus will create new opportunities and computer-recognition of personal handwriting may help in diagnosing illegible forms. But any such software will require informed programming.

Computer-generated letters are useful in the classroom to replace the teacher's handwriting, providing wall displays and further exercises to supplement handwriting schemes. However, letterforms designed to resemble handwriting schemes are usually difficult to read when they appear as a block of text in print or on the screen. The Sassoon Primary typefaces (see opposite), widely installed in school computers in Great Britain, and around the world, are somewhat different. They were originally researched and designed for reading yet they are appropriate for demonstrating the characteristics of written letters, their movement and the way they join. Various publishers have adopted them for their handwriting schemes. Letters for reading and letters for writing can now be the same, and schools can produce their own teaching material across the curriculum with uniform, legible letterforms.

As far as the balance between the use of handwriting and the computer is concerned, it is impossible to tell what will happen in the future. At present, the shortage of computers in the classroom restricts their use in the primary school. Laptops, however, are increasingly available for those with special needs, and their usage in mainstream classrooms will obviously increase. It takes time for keyboard skills to build up to be as fast as handwriting. When, how – and even if – keyboarding as a skill should be included in the primary curriculum for all children remains to be decided.

There is still a need for handwriting to be taught and to be taught efficiently. Should we neglect it, a two-tier society will emerge. At one extreme people will only be able to communicate via a keyboard, while at the other, possessors of both skills will be able to choose the most appropriate one for the task. My view is that no child, whatever their problem, should be encouraged to give up handwriting and rely exclusively on the computer, and all children, irrespective of their age and talents, should be trained to use a keyboard from an early age, and, from time to time, allowed to see their work produced on a computer giving it the status and appearance of professional print.

A critical review of a century of the teaching of handwriting

The pattern of events shows that what could have been a steady progression towards a faster, more efficient, modern handwriting has been a series of abrupt changes of direction. In the end they have solved nothing. Throughout the century, with a few notable exceptions, proponents of each innovation started by criticising their predecessors. They then launched their new ideas, with little research into the likely disadvantages of new letterforms or practices. Spurious scientific reasons were sometimes put forward to promote new ideas, and unproven theories went unquestioned. They were accepted as 'research', and were repeatedly quoted by subsequent writers.

Teaching methods and priorities have been manipulated by political theorists in pursuit of social change as well as educationists, particularly in the post-war years. This has gradually eroded the skill element and teaching expertise not only in handwriting, but also in other subjects as well. Teachers, particularly in the case of print script, have followed a course that has made their task easier in the short term without considering (or, to be fair, understanding) any adverse effects on their pupils' future.

Calligraphers seem to have singlemindedly pursued their idea of italic as an ideal model, and promoted it for general use without understanding of the problems that children and teachers might have with using it. In pursuit of their beliefs these calligraphers may have damaged their reputations, and caused considerable harm to the many children who could not conform to an italic model and were looked at as either failures or rebels. Now, instead of being consulted as to any future developments, those in the discipline of letterforms are often distrusted by many involved in education and seen as didactic and out of touch with reality. This is unfortunate because it is evident that many of those who are struggling to produce handwriting models today are hampered by their lack of basic knowledge in that specialist field. Broadminded people, with a sound background in lettering, are sorely needed to advise on the design of efficient models for the future.

The abrupt changes of attitude to joins, through the century, also show how didactic views have worked to writers' disadvantage. In 1900, when Copperplate or Civil Service models were prevalent, the pens that were used were both suitable for continuous joins, and were unsuitable for pen lifts in the middle of words. Lengthy training ensured relaxed pen holds, and cursive hands worked well, where speed was seldom important. Then, around 1920, came the sudden move against joins. Countered only by the italic of Fairbank and the simplified semi-cursive of Marion Richardson, print script prevailed, and has proven difficult to displace. Those promoting it perceived the simple

letters as quick and easy to teach, while ignoring the fact that the automating of abrupt strokes would be increasingly difficult to alter, making relaxed joins increasingly difficult to achieve.

Finally, at the end of the century, along came directives within the National Curriculum that seemed to dictate a return to the continuous cursives of 1900. In an attempt to encourage more joining at an earlier stage, a not very well thought out policy has risked putting the clock back. A reversal of policy has, once again, caused problems. Modern writing implements and the way we hold them mean that writers need to take pen lifts during the writing of long words. By apparently recommending continuously joined writing, the real needs of writers are again being ignored. Informed teachers are faced with a dilemma whether to train children in a continuous joined hand which they know will slow them down or result in distorted letters and hand fatigue later on, or teach them to join when comfortable and take pen lifts when needed – which will sacrifice a top mark in their statutory tests.

With the emphasis on models, a structured method has been ignored. Those who produce modern copy books would be wise to note, for instance, that in earlier copy books neither alphabetical order or spelling was ever confused with the early teaching of handwriting. Exercises were graded in stroke-related sequences,

The writings of Maria Montessori seem to have stood the test of time particularly well as a system of preparing children for the task of handwriting and teaching the first stages. Only the letterforms have altered during the century, whether they are printed, or made of sandpaper or wood, to keep pace with modern styles. Her methods, based on her belief that learning to write is 'stocking the muscle memory', have yet to be bettered. The great educationist's grand-daughter, Renilde Montessori, said recently: 'The full dimension of her pedagogy has not yet been fathomed'.

My response to the situation, having researched it since the 1970s, has been largely to ignore the stylistic argument (other than promoting exit strokes on separate letters from the start) and to concentrate on writing about the fundamentals of handwriting. Briefly, the essentials of the writing system need to be explained and taught, such as directionality, the movement of the strokes that make up each letter, height differentials, the two sets of letters and lastly, spacing. By stressing the implications of the physical act, and the importance of writing posture, the model becomes less important. Whether letters are round or oval or upright or slanted depends, after all, on how the hand is used. I believe that informed flexibility is better than didactic rules, allowing that children, like adults, have different tastes and innate abilities.

My own work and studies into handwriting

When I first looked seriously at handwriting in schools, in the late 1970s, my first impressions were of pain – of young children's distorted bodies as they sprawled awkwardly across their desks. This was a result of neglecting the basics of teaching of writing posture. I soon realised that infant teachers no longer taught how to form the letters, they could not even see when strokes started at the wrong place or went in the wrong direction. A visual approximation was enough. Both of these factors worried me, as a trained scribe, but, contrary to expectations, the thorny issue of the ideal model did not. My own children's problems with badly taught italic had shown how harmful a strict model could be in uninformed hands. It seemed imperative to help teachers to understand the realities of the act of writing.

My first book, *The Practical Guide to Children's Handwriting*, was developed out of these observations and the notes made for subsequent training sessions for teachers. Research was needed, but there were no accepted ways of measuring the separate aspects of writing posture, or separate features of writing, such as how joined is joined writing. My original intention was to see in what way how one writes affects what one writes. The first thing to look at was pen hold, seemingly a universal problem. With colleagues from the Medical Research Council an open-ended analysis was evolved that could be extended to include other postural aspects. This task showed us that unconventional pen holds were sometimes faster than conventional ones. It also taught me how to assess a pen hold visually, and gave me the confidence to teach teachers how to be more flexible. It also led to my belief that modern pens and perhaps modern life was affecting how children use their hands.

At the same time simpler methods were evolved to let teachers learn from observing their pupils – about paper position, for instance, in order to shock

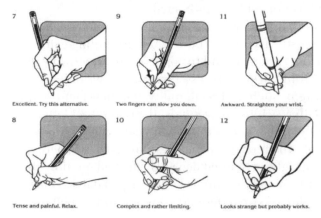

7 Excellent. Try this alternative.

9 Two fingers can slow you down.

11 Awkward. Straighten your wrist.

8 Tense and painful. Relax.

10 Complex and rather limiting.

12 Looks strange but probably works.

Some unconventional right-handed pen holds, drawn from the research project, appeared in 'Helping Your Handwriting' to assist teenagers in understanding their own problems and to try to find out what suits them best.

them into seeing how many were unsuitable and a main cause of poor posture. The best way to remedy teachers' lack of training seemed to me to teach observation rather than always to lecture theoretically. A set of telling photographs, most of them culled from my research project, where every child was photographed from several angles, helped to add a dramatic touch to any session. As for letters – they were to form the basis of my doctoral thesis.

I wanted to compare the way different models affected children's ability to join letters. Teaching print script was suspected to deter a fluent joined script, but further investigation was needed. This meant comparing the terminals (straight or with exit strokes of some kind) and number of joins or touching letters in the writing of children taught different styles and in different ways. One myth that this work dispelled was that boys joined more than girls. It transpired that they used joins differently. Girls, with more sensitivity to what they saw as neatness, avoided top joins which interrupt the top line of writing, but were more consistent in using baseline joins, so the totals evened out.

Some variations of the letter 'k' found in the writing of 400 primary and secondary pupils. The top line of characters are written efficiently in one stroke.

The second row are all written with two strokes, the third with three and the fourth are all unacceptable.

Perhaps the finding most relevant to the end of this book was that many teachers who were convinced that they were teaching a certain model, were in fact reproducing proportion, slant and other details of their own personal script. What I found overall was variability – between children in different schools taught the same model, or even in the same school taught by different teachers. Variability occurred between children in the same class and within individual's writing. Some of the children's solutions to letters or joins were preferable to those that were being taught, so I became increasingly convinced that variability was preferable to uniformity and usually led to a more efficient personal handwriting. The consultancy work that I did for The National Curriculum Council reflected these views.

The best way to disseminate all this information has been through a series of books at different levels. Most of my research papers and more serious

articles were collected in the *Art and Science of Handwriting*, but not before much of the findings had been simplified to make a pair of books aimed at primary schools and another at secondary level. These were in two parts, one for the teacher and the other to interest and help pupils. If older students understood their problems they could diagnose and correct them themselves.

During this final quarter of the century I have been persuaded to spend a lot of time lecturing on the basics of how to teach or remediate handwriting. My real interest, however, has long wandered into other fields such as the medical aspects of writing. Paediatricians, neurologists and even psychiatrists approached me to see their patients, and I ran many courses for occupational therapists. All this gave unrivalled opportunities for dealing with different problems of people of all ages. You cannot be too inflexible about conventional pen hold when you have seen children with digits missing write competently, and being exposed to all ages from pre-schoolers to geriatrics gives one a broad view of the subject. Above all it showed me how important the ability to make your mark, and communicate through writing is to the human being. Five years' study of writer's cramp showed me that this condition usually seemed to be a result of poor writing strategies and posture, first causing discomfort and distorting the written trace. Perfectionists and high achievers suffer most as pressure of work and the need for speed exacerbates the condition. The writing declines and eventually ever-increasing pain causes serious tremors or even stops the hand from holding a pen at all. This underlines the need to teach children good posture and writing strategies.

My work has taken me around the world, and my interest shifted once more to other writing systems. It worried me that in English-speaking countries although second language teaching was a recognised discipline, writing was not. There seemed little understanding of the distinct problems that writers of any age from other cultures might have, or that competent writers in their own system might need something more specific than children's copy books.

Investigations revealed the very real difficulties of those whose first writing system proceeds from right to left, but who are never taught to change to an appropriate pen hold and posture for writing from left to right. Another major problem occurs when a character from one system resembles one in another but has a different point of entry and direction. Both physical problems and letter problems echoed my own way of thinking and I evolved a method for teaching between any two writing systems. Roughly this works by comparing the rules that govern each script. Where they differ, explanation and specific exercises are needed at any age. The same for practical issues. Scripts that had developed from the use of original writing tools and materials, for brush for

instance, had required different posture, paper position or pen hold, and might need changing before attempting another script. All this taught me more of the history and universal truths of writing, and developed into one of my favourite books, *The Acquisition of a Second Writing System*.

Sequencing of strokes in characters from different scripts, from 'The Acquisition a Second Writing System'.

Then it was time to put all this into historical perspective. For that I needed to collate a huge archive of material, collected over many years. Models had been relatively easy to trace, and many of them I had already found when researching for my PhD survey in the 1980s. My study of the twentieth century required everyday handwriting, not the faultless examples found in most histories. People buy perfect copy books for investment, but they were expensive and not always relevant. Dry educational volumes could sometimes be found discarded, with out-of-date handwriting schemes, in teachers' centres and libraries, but I also needed ordinary school exercise books, and informal adult writing from around the world. The value of this visual record of the whole century only became apparent once this book took shape.

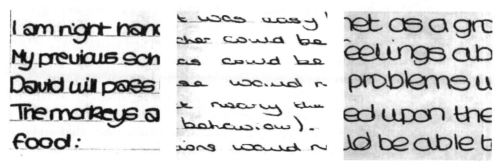

Early in the century Montessori wrote: 'The motions we make are so individual that each one of us has our own style of writing, there are as many forms of writing as there are of man'. This was never more true than in Britain at the end of the century, so it would be inadequate to show a few examples and call them representative. A contemporary phenomenum is the rounded script of teenagers and young adults (above).

Some personal conclusions

Throughout the century there have been constant complaints about the decline in the quality of handwriting. Yet is it declining, or is it just changing, and indicating that it is becoming more relevant to life in the future? Should we be deploring the situation or trying to learn from it?

If we accept that handwriting is going to be more for personal than public use and scrutiny, then surely we should be thinking about what kind of handwriting is needed. Adult handwriting, at its most efficient, will seldom include every single letter in a long word. Letters and whole strings of them, are often only indicated, yet the words are still recognisable. Once the first part of the word is clear, word endings can tail off into a barely legible scribble – providing the height differentials are retained to give the word a shape. In effect the word itself becomes an instantly recognisable hieroglyph or symbol.

Yet the parts must be learned before the whole and the whole must be internalised before it can be simplified. This means that the most important time to teach handwriting (and the only time that it is really essential) is at the very beginning, when it must be taught thoroughly. Simple, non-stylistic letterforms should be used, which train the hand in the movement and pressures that will allow it to flow naturally. That is the purpose of integral exit strokes. The importance of the different heights of letters in defining the word shape must be explained from the beginning, but other details are not only less important but may well be better left to the individual in the interest of promoting a personal hand as soon as possible. Does it really matter whether the letters are round or oval, what slant the writer adopts as long as it is consistent, or even whether ascenders and descenders are looped or not?

Few schemes, even today, recommend the teaching of fast writing. Yet search far enough, back to 1878, and you find Stoke's *Rapid Writing* – a book promoting speed as a virtue in an age where clarity and appearance were aspired to. The concept that only neat handwriting is acceptable and worthy of praise dies hard, yet it is fast handwriting that pupils need. As soon as the movement of basic letters and simple joins have been established, children should be encouraged to speed up. This will be increasingly important as they progress through the school system, particularly where written work is to be read by the writer alone. It should be seen to be as important a skill as slow neat writing. Fast scribble promotes variability and efficiency and, with a little guidance, refines itself eventually into a competent mature hand.

To teach uniform, neat handwriting is relatively easy. To advise on fast personal writing needs imagination and considerable knowledge about the act and usage of handwriting. It is at teacher education that all our efforts should

be aimed. Teachers are just as much a product of their childhood training (or lack of it), and it is the teachers' own handwriting which will be the most likely influence on classroom handwriting. As the children of the 1980s and 1990s become the teachers and role models of the new century, this is another factor to consider, alongside the design of models and use of the computer.

Attitudes to the child in the classroom have altered – as have the children's attitudes to school. Individuality is encouraged and it is clear that inflexible ideas and methods cannot succeed today, when so many factors are involved. This is specially evident when applied to the physiological aspects of handwriting. Children today require informed explanation not didactic instruction in such matters as how joined joined-up writing should be, and what pen hold might work best for them. Differences should be observed and learned from just as much as conformity. This comes with an understanding that, after the first stages, there are no absolute right and wrongs about handwriting, as long as it serves the needs of both writer and reader. To ensure that handwriting is painfree, children need to know that pain is the body's warning system. We must alert children to the importance of looking after their own bodies, and react positively to any complaints of discomfort from whatever reason.

Looking at handwriting as an international issue, we must not expect all scripts to be equally easy for everyone to decipher. Cultural attitudes to letterforms are unlikely to alter radically, even if the details and ductus of some of the more complicated national styles become simpler. Readers should be able to decipher personal variations of letterforms from their own national styles as well as scripts that conforms to other national models. However, they may have problems with personal variations from an unfamiliar style. This will be exacerbated when deciphering scripts written in a foreign language when writers from other countries simplify the different common letter combinations and word endings that occur in their own language.

This is not the place to discuss the use of the computer as an aid to creative writing, nor even its advantages in the planning and executing of many kinds of written tasks. As such software proliferates, handwritten tasks, particularly in the secondary school, are decreasing. Yet examinations are still required to be handwritten, and to a great extent, notes must still be taken down by hand. A balance must be reached and this is one of the most important tasks for the planners in the next decades. They will need to be clear-sighted enough to withstand the commercial (and sometimes political) pressures and consider first of all the real needs of the next generation of students in their school and later in their differing adult lives.

50 SORTES D'ECRITURE

4

bons comme lui, en oubliant les torts qu'on peut avoir envers vous, en obligeant vos fieux et en leur rendant tous les services qui sont en votre pouvoir.

2ᵉ. Leçon.

Dieu est juste, c'est à dire qu'il récompense chacun suivant son mérite, il n'a de préférence pour personne, il tient compte de toutes nos actions, quand bien même nous voudrions les lui cacher; car il

The first two examples in 'Choix Gradué de 50 Sortes d'Ecriture' (illustrated above) show the two styles of script that have influenced French handwriting up until the present day. Copperplate written originally with a pointed quill, and Ronde with a square cut quill, each produced specific deviations when written at speed. These variations have become more pronounced as the two models have been modified for modern pens. Below are the final examples presented for pupils to decipher.

CHAPTER 11
Handwriting around Europe

IT IS NOT POSSIBLE to represent the progress of all the major countries of Europe in detail in this chapter, so samples have been chosen to emphasise diversity in the development of models and attitudes. In this way we can all learn from each other's successes and failures (if we want to).

In the nineteenth century, the discipline of the quill, and the need for handwriting to be universally legible kept handwriting around the world more uniform than it is today. Yet the handwriting of a whole nation, at any given time, was never entirely uniform. Despite the strict training and use of the various national models, the individuality of strong minded and creative writers has always broken the contemporary mould. Differences in education and social standing, as well as the individuality that evolved with the need for speed, have also been reflected in written forms and ensured variety.

An unusual genre of books illustrates the variability of adult handwriting. In France, in the middle of the last century, a book entitled *Choix Gradué de 50 Sortes d'Ecriture* was published. It was aimed, according to its title page, at the Ecoles Primaires. Its purpose was to accustom children to adult handwriting and gradually introduce them to more complex personal scripts until, presumably, they were able to decipher the near scribbles of the final examples and profit from the worthy texts written in them. Professor Michael Twyman described this book and the similar *Lectures Manuscrites Instructives et Amusantes à l'Usage des Enfants* in 1997, saying: 'The presentation of a range of scripts was common enough in the writing manuals of the 18th century. Those who studied handwriting seriously were expected to be able to write in different scripts and to know something of the use of different letterforms. This was true of some children in the nineteenth century but such accomplishments had little to do with the ideas underpinning Soulice's *Lectures Manuscrites*. First the book was designed as a reader, not a writing manual. Secondly its originator was more concerned with problems arising from reading scripts that were written more or less carefully and formally'. Twyman noted that he was not aware that this educational approach was applied in Britain, though there were Dutch and German publications of a similar kind. To that should be added the Danish books published at the turn of the century to help people accustom themselves to reading handwritten texts after that country changed from Gothic handwriting to the Latin script.

MULHAÜSER'S MANUAL OF WRITING

Mulhaüser's Copperplate (referred to as Anglaise in other countries) letterforms and graduated exercises were accompanied by detailed practical instructions. Every aspect of classroom management was prescribed. Under the title 'Simultaneous combined with monotorial instruction', a method of dealing with classes up to 70 pupils was given for teaching with the help of class monitors. A complex drill for all aspects of writing posture ended with the order to stop writing. Correct paper position was prescribed (for right handers only), and a proper pen hold was described with 13 separate instructions.

The historical background

The development of handwriting in different countries was, and still is, inter-linked, new initiatives in one country affect others. In 1829 M Mulhaüser was appointed to inspect the writing classes under the superintendence of the Genovese Commission of Primary Schools. His subsequent manual and methods spread first to other cantons of Switzerland, and then to France. In 1842 it was translated into English. *A Manual of Writing* was to influence teaching methods worldwide. Some of his illustrations were still being used in copy books well into the twentieth century.

Mulhaüser had perceived that 'the teachers were contented with requiring the pupil to imitate a specimen of writing, without any effort on their part to enable him to comprehend the elements of the forms presented for imitation'. The translation continued: 'M Mulhaüser detected the errors which lay at the root of the instruction: the children were required to perform the complex before they were able to accomplish the simple – the labour of analysis was imposed on them before they had become familiar with the easier process of combination – the faculty of imitation and the mechanical dexterity of the fingers were exercised without any assistance from the constructive powers'.

The method consisted of three parts: analysis, classification and synthesis. It was explained this way: 'The written characters are decomposed into their elements, and the elementary forms classified so that they may be presented to the child in order of their simplicity, and that each of them may be copied separately. The synthesis, or recomposition of these elements into letters and words, is the process by which the child learns to write; he combines the forms which he has been accustomed to imitate; he recognises each separate simple form in the most difficult combinations; and, if he err, he is immediately able to correct his error. If the master himself should make a mistake, the child would probably rectify it without hesitation'.

TRADITIONAL RONDE MODELS

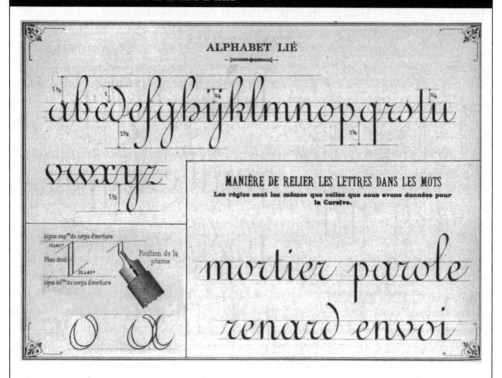

Above: Ronde letters, from Meyrat's 'Principes d'Ecriture', written with a broad-edged nib, accentuate the top-left entry to the round letters 'o a d' etc. Below: Exercises from Regnier's 'Methode Générale d'Ecriture' illustrate confusion between the under and over curve. The words 'la saison' show how both these facets of the model can still affect modern hands while the letterforms opposite retain the broad-edged pen's entry.

THE EFFECT OF RONDE ON NATIONAL MODELS

Belgian model by Paul Cooreman showing the influence of the Ronde, 1947, and a page from André Casteilla's French copy book showing a model based on traditional Ronde adapted to the ballpoint pen.

A French teacher illustrates the model's deficiencies with the entry and ductus of the round letters.

Two Italian Ronde-based models. All alphabets, except bottom left, are reproduced from Gray (1976).

FRENCH HANDWRITING EARLY IN THE CENTURY

Rappelle - Toi !

D'Alfred de Musse

A poem copied out into an autograph album at the turn of the century.

Above: An exercise book dated 1913 which includes both the student's and the teacher's handwriting. The outside and inside cover illustrate the taste and moral teaching of the age.

ilvwxyzkocenm hbdpqrstufgja

Print letters, like those from 'Cahier D'Ecriture Baton' 1931, were taught for professional use.

FRENCH HANDWRITING AT THE END OF THE CENTURY

une veste — un ticket — une banque

*mal
écrit
pas assez
soigné*

*Nous nous lavons à grande
brossons les dents, nous déné
nos cheveux et nous nous som*

Teachers may still use a traditional handwriting and model in class but times are changing rapidly.

Many adults have simplified their handwriting. They find the complex traditional cursive inefficient, difficult to speed up and inappropriate for use in the modern world.

Contemporary French students' writing seems to echo the roundness of their British counterparts.

GOTHIC SCRIPT IN GERMANY

A sample from an exercise book dated 1873 where the script is very close to the models shown below.

Above: Examples from 19th-century copy books. Below: A student's exercise book dated 1900.

MORE RECENT GERMAN MODELS

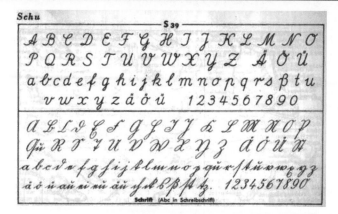

Above: Alphabets used to represent handwriting in a dictionary, 'Der Sprach Brockhaus', in 1951 when Gothic script had already been phased out. Below: The model designed by letterer Renate Tost.

Schulausgangsschrift

1968

ABCDEFGHIJKL

MNOPQRST

UVWXYZ

abcdefghijk

lmnopqrsßtu

vwxyz

HANDWRITING IN GERMAN SCHOOLS TODAY

Eu ist in Mutters Hut
Olaf lacht.

Above: A teacher and pupil show how strictly the model is still adhered to in some schools. Below: A class of fourteen and fifteen year-old pupils, writing to an exchange class in England, show how quickly many of them have abandoned the traditional model. Both schools were in Hamburg.

I hope you I will have a nice time

I hope we will have a sunny week or

I hope you will like Hamburg and you

I hope the sun will be shining and

I hope we'll enjoy the time when you

I hope you will have a nice stay

I hope you will like our activities here in H

I'm sure we will have a nice time toge

I hope that we all will become good fri

I hope we will have funny days! M.

GERMANY AND AUSTRIA

2 new addresses
UNIVERSITY:
Wundtstr. 9/1R-1
01217 Dresden

I'd be happy to hear
to be in Germany.

Deu
Kůnst

Left: A German student in the late 1990s whose writing might easily be mistaken for her English friend's. Above and below: The haken, a sign that differentiated 'u' from 'n' in Gothic, is still occasionally used as a courtesy to avoid confusion.

Umschläge
Kaugummi
T-shirt

Österreichische Schulschrift
1969

a b c d e f g h i j k l m n
o p q u r s ß t u v w x y z
A B C D E F G H I J K L
M N O P Qu R S T U V W
X Y Z . : ! ? , , . ' - ()
1 2 3 4 5 6 7 8 9 0

Österreichische Schulschrift
1995

a b c d e f g h i j k l m n
o p q u r s ß t u v w x y z
A B C D E F G H I J K L
M N O P Qu R S T U V W
X Y Z . : ! ? , , . ' - (,
1 2 3 4 5 6 7 8 9 0

Wir erleben braune
Tage in grün - gold
herbstlicher Landsch
und denken an e.

Alf Wurfl
Des Mahl

Austrian and German models were similar. Two Austrians, who went to school together in the early 1940s, had then to learn to write both Gothic and Latin scripts, developed different personal writing.

Variations in the Nordic countries

Sweden changed from Gothic to the Latin alphabet in the first half of the 19th century, and Denmark, Iceland and Norway towards the end. The way these countries have evolved various simplified models from their Copperplate roots makes a useful comparison with the solutions of other countries.

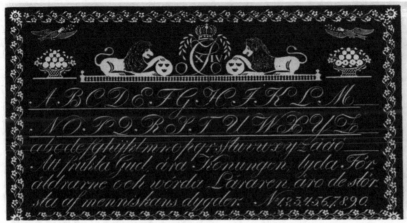

18th-century handwriting model from the Kalmar Museum, Sweden, reproduced from Lindegren 1976.

The pseudo-scientific justifications for changing models sometimes sounded much like those propounded in Great Britain. The historian, Trond Berg Eriksen, wrote an article in 1993 based on research into the introduction and implementation of Alvhild Bjerkenes' Marion Richardson-like handwriting model, Formskrift. Specially in the period from 1947 to 1962, this managed to take over from the traditional models. Ole Lund, translated his review of this article *Form-skrift*, saying that Eriksen found cynical or naive justifications for the letterforms that vaguely referred to science or procured favourable statements from medical doctors or psychologists. Lund continued: 'These arguments can be found in the discourse on handwriting models for schoolchildren in post-war Norway. This kind of rhetoric was applied by all sides of the debate, and the ergonomic arguments often mixed with political, moral, social hygienic and aesthetic arguments – as well as more pragmatic arguments'. None the less, the progression of Nordic models is impressive.

Funktionell handstil 1952.

Skrivkursen Pennan 1960.

DEVELOPMENTS FROM ALVHILD BJERKENES' FORM-SKRIFT

abcdefghijklmnopqrstuvwxyzzæøå

Alle små mus tok beina fatt.

Alvhild Bjerkenes adapted Marion Richardson's ideas for Norway and later Denmark. Her separate letters developed into a simplified semi-cursive. In 1976, with Cristian Clemens, she wrote copy books for Denmark. The calligraphy for her later Norwegian copy books was by Jacob Rask Arnesen.

a b c d e f g h i j k

a b c d e f g h i j k

From Alvhild Bjerkenes' 1975 'Formskrift', published in Norway.

From the 1976 'Formskrift' by Alvhild Bjerkenes and Cristian Clemens, published in Denmark.

From the 1986 'Vi Former Skrift' by Alvhild Bjerkenes with calligraphy by Jacob Rask Arnesen.

TRANSITION FROM TRADITIONAL TO MODERN

abcdefghijklmnopqrstuvwxyzaöå
ABCDEFGHIJKLMNOPQRSTUVWXYZ
abcdefghijklmnopqrstuvwxyz æøå

Kåre Oftedal's traditional and simplified modern models presented together in 1983 in Norway.

fleste af ordene i dette hæfte
er meget lette ut dele. thrs

Inger la Cour's 1984 more traditional Danish monoline model retained the older form of the letter 't'.

Hører du ei klokka?

Jakob Rask Arnesen's letterforms (notice the 'k') from Moriggi and Arnesen's outstanding copy books.

From Annita Odman's 1987 'Min Skrivstil' series of copy books for Finland.

ITALIC IN SWEDEN AND ICELAND

abcdefghijklmnopqrstuvwxyzåäö

abcdefghijklmnopqrstuvwxyzåäö

Så gick det lilla knyttet ut på stranden
och fann en snäcka som var stor och vit,

att man kan använda klocka

för kompass för att leta ut nor

Kerstin Ankers' italic model was introduced into Swedish schools in 1972. Calligraphic standards were high with four staved lines retained well into secondary level. Over-emphasis on appearance led to slow and painful writing. By the late 1990s a more relaxed attitude to handwriting models emerged.

Þrettánda æfing
Teiknaðu Marsbúa á blað. Byrjaðu á
kringlóttum haus með sperrtum
eyrum og svipmiklum augum.

áéíóúýjö

G SE Briem's 1988 Italíu-skrift copybooks for Iceland have produced remarkable results. His model letterform combined with his light-hearted illustrations have enlivened the teaching of handwriting.

Learning from the Nordic countries

These countries provide a useful comparison with what was happening in Great Britain and elsewhere over the past half century. Bjerkenes, who began by copying Marion Richardson's letterforms, simplified her models to an oval print script followed by a simplified cursive. Her work was followed by several others in Norway, and Denmark. Sweden eventually chose to develop italic models making more of a break with its traditional letterforms. Yet, despite initial similarities, the progression of letterforms differed from those in Britain. Some answers may be found from the designers who produced the models. Some, like Jacob Rask Arnesen, were trained in lettering, and seemed to take the real needs of children into consideration. Their modernised cursive models retained an echo of traditional forms combined with a well-designed simplicity.

Their italic models seldom resulted in the contorted triangular forms to be seen in British schools. Part of the answer may lie in different attitudes to aesthetics, part to the more gradual progression to better designed, modern, monoline models. Perhaps the teachers were more thoroughly trained, or children were more effectively taught, so the effect of print script was less severe, preserving the long tradition of a graceful cursive hand.

Attitudes to writing posture and school furniture have been far more informed in Scandinavia. Following Dr A C Mandal's important research into postural effects of furniture, Christian Clemens has written widely in Denmark of the importance of appropriate furniture. His work reveals a depth of knowledge sorely lacking elsewhere. His advice is not always adhered to in Denmark and Sweden, and the full advantage of the new ergonomic furniture to be found in their schools is not always realised, but all this is an indicator of a deeper knowledge and respect for the act of writing, and the effects on children's bodies, than is to be found in many other countries.

Illustrations of posture and furniture, and letterforms from Christian Clemens' 1989 'Bedre Handskrivning'. Clemens created a writing system for Greenland in 1983 and the Faroe Islands in 1993.

NORDIC HANDWRITING

You were lucky ...tter to Carduu, weather when yo ...is sleit at the Iceland. Later it ...orted it te you.

Writers from Iceland and Denmark show the influence of their traditional models.

I hope these two. ...lly hasty reme ...se or you.

I am sending yo bookes I wrote at card. I am glad

Two Norwegians, one with a traditional writing and the other modern. Both are typographers.

...e words befr and the comf... ...n there two

You will also to talk to the break at 9.30

Two Swedish writers, one with a more traditional script, the other, a teacher, has an italic writing.

Det var p

Det var på

Det var på en

Det var på en

Det var på

The first of these six examples shows a Swedish school's italic model, though few of the pupils seemed to follow it. Some chose more traditional forms while others had round upright handwriting.

Different attitudes to models

Neighbouring countries still have very different attitudes to the teaching of handwriting. Some countries, the Netherlands for instance, still retain a traditional model, and it is strictly adhered to. Switzerland has had a policy of a different model for each canton, although they are in the process of altering this. Hungary, on the other hand, made concerted efforts to research the effects of traditional and modern models before deciding on reform.

Above: From a copy book c.1950, and below it some present day writing describing the effects of altering models. Right: Models can be looked at in other than aesthetic ways. A research psychologist illustrated a different way of considering models. Meulenbroek showed in 1989 how a slight modification could lead to improvement in forms, with slightly curved trajectories leading to an easier writing movement.

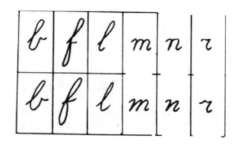

AROUND EUROPE

Date che non devo dimenticare

Anno Scol. 1937-38. XVI

novone nanino nasta

Addentare una mela

A traditional Italian script from the 1930s and a present-day child learning (with difficulty) from a modern model. This will have to evolve into a more efficient handwriting in order to be speeded up.

a b c d e f g h i j k l m n o p
q r s t u v w x y z
A B C D E F G H I J K L M N
O P Q R S T U V W X Y Z

Above: Swiss model from Zurich. Below: Example from a Spanish copy book, and an example of an adult handwriting resulting from a traditional Spanish model.

Logroño Burgos y Santander

(Muy queridos todos Re. a carta y estamos contento

A maci ír 1.

hosszú nyakát nyújtogatja

A maci ír

hosszú nyakát nyújtogatja.

Writing is not only a mirror
of the character of the writer
and of the period in which
it was written, it leads anyone
studying it into the glamorous
regions of bridled passions, whe

Itt küldöm az angol szöveget, de
a magyar fordítást is. Ez utóbbit

The changes in Hungary over only ten years are illustrated by two editions of 'A Maci Ir', 1976 and 1985. Whatever the model, creative people will develop their own script. Above: The handwriting of the letterer Imre Reiner, and below it, that of Péter Virávölgyi who researched and designed the more italic letterforms for the 1985 'A Maci Ir'. A more traditional Hungarian script appears below.

— I shouldn't have said that should I ?
but I always tell you everything

Conclusions from a brief survey of handwriting around Europe

This brief survey of handwriting around Europe has thrown up several important points. Some of them are quite unexpected. The faults of some traditional models have been revealed, especially where they have not adapted well to being written with modern pens and at speed. In tracing the Ronde origins of many of the models, it was demonstrated how the top left entry to the round letters of the alphabet (adgq), originally the result of writing with a broad-edged quill, has become entrenched. This has led to inefficient joins between letters and caused the writing to fall apart at speed. It has also been shown how the traditional looped cursives have led to the erosion of the over curve, which distinguishes the 'n' from the 'u'. This has also contributed to illegibility of handwriting, particulary at speed. At the other extreme, some fine modern models have emerged. These provide ideas and alternative solutions for letterforms in the next century.

The real surprise has emerged from the handwriting of this new generation of students. Whether they have been taught to adhere closely to a national model – the French traditional cursive, the German modern cursive or the Swedish italic, for example – it does not make much difference. A proportion of teenagers seem to discard any trace of their taught model and develop a round personal writing almost indistinguishable from their British peers. It seems that soon it will no longer be so easy to tell the nationality of a writer.

It is important that we take notice of what is happening, and what these young writers are trying to tell those who are educating them. In some cases it is obvious that they have found their national model teaches a traditional style of writing that is inappropriate for their needs. In other cases they have been taught a style that seems either inoffensive or even positively well designed and ergonomic, then are they saying that they would rather not be taught any strict model? Perhaps the round writing is a result of modern pens and the way that they must be held in order to function efficiently. Whatever the reason, even if it is just a manifestation of worldwide pop culture, the younger generation hold the secret of how to encourage an appropriate form of handwriting that will coexist with the computer. In imposing an older generation's tastes we may risk hastening the demise of writing.

Of course, children still need the practical guidance that will make the act of writing relaxed and painfree. They still need to learn the basics of letter formation, heights and spacing so that if nothing else they will be able to read their own writing. This study, however, shows that we should all be careful what we impose on the next generation – without asking for their views.

20

Washington died 1799.

Washington died 1799
Washington died 1799
Washington died 1799
Washington died 1799
Washington died 1799
Washington died 1799
Washington died 1799
Washington died 1799
Washington died 1799
Washington died 1799
Washington died 1799
Washington died 1799
Washington died 1799
Washington died 1799
Washington died 1799

S A Potter, a page of whose copy book appears above, likened the classroom drill to: 'The military training of a squad of men moving at one impulse'. Intensive writing exercises were recommended as a cure-all discipline for unruliness and all forms of deviant behaviour. Tamara Thornton wrote in her book, 'Handwriting in America', (1996): 'It was the schools' job to reform delinquents, assimilate foreigners and produce workers of the right sort to meet the demands of business'.

CHAPTER 12
America and Australia

T HIS FINAL CHAPTER concerns handwriting in the USA and Australia. This
allows a comparison between these two countries, one that has only just
begun to tackle the modernisation of handwriting, while the other has already
experimented with various solutions.

'At the beginning of the 19th century, the influence of English styles was
considerably enhanced by Joseph Carstairs (see page 20), who taught a
fashionable clientele in Bond Street,' so wrote Aubrey West in *Written by Hand*
in 1951. Stanley Morison explained also in 1951, in his book *American
Copybooks*: 'The original teaching of Carstairs, naturalised by Benjamin Foster,
met with great acceptance in America after 1830'.

*An exercise written by Agnes Jay in 1877 in a Potter and Hammond copy book. The cover of her copy book
shows it was in the Ladies Series. The left-hand cover relates to the copy book on the opposite page.*

The Spencerian system of penmanship

From the middle of the nineteenth century there was a proliferation of writing masters each with his own publications and several with their own academies or business colleges. Of the followers of Benjamin Foster, the best known were A R Dunton and P R Spencer. These two were rivals and bitter enemies, though there was little difference that we can judge today between their two 'flourished, elongated and heavily shaded scripts' as Morison calls them. It is Spencer who is better known to posterity. Approved and adopted by the business community, he lent his name to the mid-century American hand.

Above: Spencerian alphabets. Left: P R Spencer's signature. Below: Samples from Payson and Dunton's 'Premium Penmanship' and Platt 'Spencer's Practical Penmanship' allow a comparison to be made between the two similar hands. At the bottom of the page: lines from Payson, Dunton and Scribner's 'Penmanship'.with the copy book's exemplar reproduced by Henry Davis Jay in 1861.

The Palmer method of cursive

=== *The Palmer Method* ===

LESSON 50—Drill 52

e, study and practise this drill faithfully. Count 1, 2, 3 for capital J and make sixty to seventy l

Drill 53

An exercise from A N Palmer's 'The Advanced Edition Palmer Method of Business Writing'.

'Developed in the 1880s and 90s the Palmer method had begun to displace the decades-old Spencerian. By the second decade of the new century it reigned supreme', wrote Tamara Thornton in *Handwriting in America* in 1996. Palmer discounted the philosophical train of thought and believed in 'imprinting the memory of motion on the muscles'. Palmer simplified letterforms much as Vere Foster had done in England, saying that: 'No attempt is made to make the penmanship more beautiful than is consistent with utility'. His influence remains today in models such as the Zaner-Bloser cursive (below). This is probably still the most widely used model, at least in U S public (state) schools.

A Zaner-Bloser Palmer alphabet and advertisement reproduced from their centenary catalogue in 1988. This is still widely used as a model in schools preceded by manuscript (ball and stick) for use with infants.

185

The advent of manuscript

Marjorie Wise, a student of Edward Johnston, assimilated the new ideas about simplified letters, prevalent at the time in England. According to Thornton (1996) she: 'Popularised the new philosophy and technique when she arrived in 1922 to teach manuscript writing at Teachers' College, Columbia University'. These letters were used as a preliminary to the accepted national cursive models, and gradually became more extreme giving rise to the term 'ball and stick'.

Above: Marjorie Wise's signature, and an inscription in a book presented to her by Fairbank. Opposite: Varied forms of manuscript used in Wisconsin from Gray (1956). Below: A typical manuscript alphabet from 'The Junior Instructor' (1936).

Italic in the USA

Paul Standard introduced italic handwriting into the United States in 1932. Lloyd Reynolds later inspired a generation of students at Reed College, Portland Oregon.

Right: A Lloyd Reynolds weathergram.

❧ The flooding river takes to the freeway

a b c d e f g h i j k l m n o p q r s t u v w x y z

good handwriting is a lifelong joy!

Letterforms from Getty and Dubay's 1991 italic handwriting scheme Write Now.

Italic has yet to gain general popularity despite several good schemes that have been developed and used in schools. These include Eager (1967), Taipale (1990), Getty and Dubay (1991), and Barchowsky (1997). Nan Jay Barchowsky's monoline italic model, accompanied by a practical classroom method, has brought italic up to date with a digitised typeface and CD rom.

Left: An illustration from Barchowsky's publication, 'Fluent Handwriting'. This shows that she is just as concerned about the practicalities of writing as she is about letterforms. The script is in her computer-generated font. Nan Jay Barchowsky's own fast, personal writing appears below in an excerpt from a letter.

Teachers need to be informed, and not let workbooks do the teaching for them.

Variability

Independent schools have long adopted other models. This adds to the variability of American handwriting. The Calvert School, day and home school (correspondence), for instance, founded in 1897, developed its own model which is still in use, virtually unchanged, to this day.

The Calvert School model, the childish writing of a Calvert pupil c. 1940 and the resulting adult hand.

The examples above are from a school year book inscribed by girls of a graduating class in 1948. They show that in a private school, where there was less insistence on adherence to the national model, these school leavers showed few traces of the Palmer cursive that many of them had originally been taught.

The modernising effects of D'Nealian

D'Nealian™ Manuscript

a b c d e f g h i j k l m n o p q r s t u v w x y z

In 1965 Donald Thurber, a teacher, began to doubt the wisdom of teaching ball and stick to infants. He found little research evidence to support what had been going on since 1922, when those simplified letters had first been introduced into American schools. He developed a more flowing set of letters aimed at eliminating many of the problems resulting from the ball and stick model. In 1983 he described how: 'Learning is accomplished on a continuum without a break in the developmental process. Ninety percent of what the child learns in forming print letters will carry over into later cursive writing. With the addition of connecting strokes, manuscript print becomes cursive when the child is ready. No longer is there a set transition time for children to unlearn ball and stick lettering before moving on to cursive writing. If the children have the motor skills together with the need or interest, they can readily switch from continuous print to cursive'.

D'Nealian Handwriting (a title developed from Thurber's own names – Donald Neal) has made considerable impact on schools across the country. Recent editions provide teacher feedback and linked projects, combined with a progressive programme for teaching handwriting. Thurber's attitudes and less static separate letters (note that his cursive is still Palmer-based) have influenced views on handwriting in the USA. He revealed recently that he is considering major innovative developments in attitudes to letterforms, joining, and practical matters such as pen hold.

D'Nealian™ Cursive

Palmer-based script today

With the model for state schools predominantly a Palmer script, the need for modernisation is acknowledged, but there is as yet no concensus for change.

From left to right: A writer in her eighties, a teacher and a high school student show Palmer scripts today.

The high school students above show they have all learned a Palmer cursive yet have varying perceptions of what is neat or good writing, and have found different solutions to developing faster, simpler styles.

Personal handwriting

The high school teacher who supplied the examples below, remarked: 'We do not trouble about handwriting any more. Everyone types their papers'. Their work shows how they struggle to achieve fast enough, legible writing.

High school students show the difficulty they have at speed, unless they radically modify their learned style.

Like most people who have learned a complex cursive, intelligent adults with a need for fast writing, and impatient with the cumbersome style that they were taught, have long developed their own simplified scripts. It is no longer possible to say that American handwriting can be instantly recognised.

The US is a decade ahead of other countries in the use of computers in the classroom. If the teaching of handwriting gets progressively ignored, this notice, found in a high school, may be an indicator of the future for handwriting.

An academic's fast personal handwriting. *A notice found in a high school.*

EARLY AUSTRALIAN COPY BOOKS

Western Australian Copy Book No. 1

win | win | win | win
win | win | win | win

Adelaide
Copy Book.

win win win win
win win win win

Early state copy books followed contemporary ones from the UK. There were probably many less formal, locally produced ones, and it seems that some, like the Philip's one below, were imported.

Ancient Aboriginal Artefacts

Book 4 PHILIPS' SEMI-UPRIGHT COPY BOOKS 10

Kent, nearest co. to France.
Kent, nearest co. to France.

Australia at the turn of the century

At the turn of the century there would have been little difference between handwriting in Australia and Great Britain. Copy books were markedly similar, and it also appears that some children used imported ones.

Controversy raged about the details of models, just as elsewhere in the world, as can be seen when R Hope Robertson, a Senior Inspector, put the case for upright writing and ambidexterity in the *Educational Circular* of June 1899. Dealing with the projected new system of upright penmanship Robertson stated: 'We find that the evidence which has been produced in its favour is conclusive, and that the results arrived at have been the outcome of lengthy observations in hundreds of schools, with hundreds and thousands of children in England and Europe. ... It has been proved by many indisputable medical authorities that sloping writing causes widespread and irretrievable injury to spine, eyes, chest, and hand, increasing to an alarming degree the diseases of spinal curvature, myopia, consumption, and writers' cramp'. There was no reference to actual international research, and the reader is left to wonder today which so-called expert made his way to Perth and persuaded the educationists to change from the more usual slanting hand. J A Miles, later to become an Inspector, disagreed especially with the policy of ambidexterity, as he described in a typed manuscript entitled *Some Impressions and Experience of Western Australian Education 1899 – 1936*. He attacked the new system in a later edition of the *Educational Circular*, despite being told bluntly that he had to carry out the department's instructions and keep his opinions to himself.

Prize winning handwriting dated 1888, from a Western Australian collection.

Set 3 Composition 2.9.24. Murray Anderson.

"Rabbits in the Bush".
The rabbit is a very fast runner, and can
jump a long way, but not very high. They
all like to be together, and trouble the
farmer, by eating the wheat and grass.
They dig their burrows in sandy country,
and generally a number of them are found
in one patch. They are very frightened little
animals, and run when they see a person,
or a dog, coming.
corrections and

Correspondence school composition written by ten year-old Murray Anderson in 1924. From 'Spin a Woolly Yarn' self-published by Ruth Anderson in 1990. Below: From a South Australian farmer's diary.

NOVEMBER 1918

Month 30 Days

11 MONDAY 315-50

Shearing today shore
88. 88. Rang up Capt Haig this
morning and got permission
to go to camp on Wednesday.

Armistice news came through
tonight

12 TUESDAY 316-49

Shearing today knocked
off at dinner time went up
the town this afternoon
great peace celebrations see
the boys leave for camp

194

The first half of the twentieth century in Australia

Traditionally, each state has been responsible for the details of its own handwriting policy. An excerpt from an Education Department curriculum document, dated 1908, found in a Western Australian library, stated: 'The ordinary written work must be carefully supervised with a view to securing, not copper-plate neatness or absolute uniformity, but reasonable neatness and rapidity combined with perfect legibility. ... No particular system of writing is prescribed, but the system adopted must not be too angular, nor must the slope be excessive. No system will be approved of which does not tend to produce rapid as well as legible handwriting'. Not too much freedom was permitted, however. Posture was taken seriously: 'No twisted, bent or slouching attitudes must be allowed'.

By 1936 new ideas appeared in the curriculum alongside the usual strictures about posture and pen hold: 'The principles essential for the fixation of this habit are exactly those that mark the learning stages in the habituation of any new process, viz., focalisation and repetition with attention. ... It will be seen that, in the learning stages of the writing habit, there must be a considerable demand on the nervous energy of the child'. Short periods were recommended at favourable times of day. The letterforms showed that the upright policy was short lived.

Some sample words showing how the loops of tall letters cross on the line, and curved downstrokes from the letters 'a' 'd' and 'o' are joined to the upstrokes at about a third of the way down from the top of the line. From the 1936 syllabus for Western Australia.

Until the middle of the century the state models were similar, but then they began to diversify. Commercial publications proliferated once state education departments ceased to produce their own copy books. In Queensland, for instance, official copy books ceased to be issued in 1971. Soon after, several of the states, notably South Australia, New South Wales, Queensland and Victoria, started researching in order to revise their handwriting policies. All four states produced comprehensive documents, citing mainly American and British research, as well as reviewing Australian work. As for styles, the eastern states tended to stress what they thought successful in England, emphasising italic, and Tom Gourdie happened to lecture in Australia at an opportune moment about the benefits of italic writing. However, italic had already become unpopular in the UK and been replaced by less stylistic letters.

DEVELOPMENT OF MODELS IN NEW SOUTH WALES

quick brown fox jumps over the lazy dog

a quick brown fox jumps over the lazy dog faery

Recommended script (print) and cursive from the 1925 curriculum.

a quick brown fox
jumps over the lazy dog

In 1952 the script was altered and expanded, but the cursive was unchanged.

A quick brown fox jumps over the lazy dog.

In 1961 the script was unchanged except for an ascender height 't'. From then onwards this form seems to have been adopted by NSW, thinking that it was easier for children to have to learn only two letter heights. This alters the word shape and can make personal writing less easy to decipher. At the same time a modified cursive was introduced into schools.

the

THE SMALL LETTERS u y v w a d g q c e o
f j s n r m h k b p l t i x z

toy yet you yy aye toy toy yet you yy

In the 1983 'Writing K-12', NSW introduced a compressed, elongated model, with italic overtones.

Western Australia and South Australia

Western Australia waited, retaining a traditional cursive. Many schools taught a relatively relaxed hand, within a structured teaching method.

Hardly had she spoken the last words 2

Hardly had she spoken the last

Hardly had she spoken the last u

1. Slope forwards.
2. Parallel lines
3. Bottom line touched by all letters.
4. Size: all letters evenly at ⅔ + ⅓ size.
5. Spacing: all letters evenly spaced.
6. Safety-pin joins

Western Australian pupils' handwriting and that of a teacher, listing some of his classroom rules.

South Australia's attitude has always been the most liberal towards curriculum and inspection matters. They adopted a simpler model in 1983 but their policy document revealed how they differed from the other states. On style it is refreshing to read: 'Children can be introduced to alternative styles of handwriting which use the same technique as South Australian Modern Cursive, such as Italic, Copperplate and Looped Cursive. If children are given the opportunity to experiment with alternative styles they may develop a preference for a particular style or certain characteristics of a style, and incorporate them into their own style'. Just as important was their attitude to pen lifts: 'Pen lifts occur naturally in handwriting even though the writer may be unaware of them. These natural pauses relax the hand and help avoid illegibility. Individuals develop pen lifts to suit their personal style and technique. These will occur at various intervals within words but not always between the same letters. ... It is unrealistic to insist on long lines of continuously linked letters'.

Roast pork and apple sauce

From South Australia's 1983 handwriting curriculum document.

197

Queensland and Victoria

Queensland adopted a Gourdie-style italic in 1984. From then on children were encouraged more towards calligraphy than everyday handwriting. This was also happening in private schools all over the country. In one well-known boy's boarding school, secondary students were indeed producing beautiful examples to decorate the walls but, 29 out of 30 boys (plus the teacher) in one class confessed to pain when writing. This is unacceptable, but the teacher's attitude was that handwriting was a discipline so of course it was painful.

Italic model from 'Teaching of Handwriting in Years 4 to 7' by the Queensland Department of Education.

Victoria launched perhaps the most ambitious project of all in 1985. Their model was a mix of italic and traditional forms such as open 'b' and 'p'. It was accompanied by an excellent teaching booklet and a training video. There were inservice training courses throughout the state to ensure the teachers were accustomed to Victorian Modern Cursive, something that did not happen when it was introduced in Northern Territory and finally Western Australia.

The Victorian Infant Cursive from 'The Teaching of Handwriting', by the Education Department of Victoria.

New Zealand did its own research before modernising, and have ended up with a relaxed print by 1998.

Standardising handwriting

By 1989 the issue of standardising handwriting country-wide was being raised. Some people were worried that slight differences in some letters might disadvantage children who moved inter-state. Others felt that these were acceptable. Already inspectors in some states were more concerned about adherence to their model than more important issues. By trying to impose the Victorian Modern Cursive on states, some of whom were unwilling, all the attention risked becoming focussed on details of the model rather than good teaching method. The model itself came in for criticism. Teachers found it difficult, children even more so. An educationist in W A said: 'It is laborious, doesn't flow, is over-spaced because of entry strokes which are not understood, but the only thing in its favour is that it does seem to retain more joining than print script'.

HOW WE TEACH HANDWRITING			
SA	b	f k	z
VIC	b	f k	3
NSW	b	f k	z
WA	b	f k	z
TAS	b	f k	z
QLD	b	f k	3
NT	b	f k	3

The handwriting of a child and a teacher in Northern Territory illustrate how the unaccustomed entry and exit strokes of the Victorian Cursive model caused confusion and led to wide spacing between words.

Comparing America and Australia, America has kept, unchanged, the Palmer Cursive in most public schools and diversified increasingly of late in private schools. The students are demonstrating that there is a need for a simplified model and good method to ensure a faster writing for the usages that a personal script will require in the computer age. Without this, confidence in handwriting will be lost, along with teacher expertise. The skill will gradually be squeezed out of the curriculum, and there will be little choice but to succumb to the computer lobby. Maybe this is what will happen eventually, but the choice between hand and keyboard must be retained as long as possible.

In Australia, when most states decided to modernise their handwriting, research was undertaken but, with the exception of South Australia, there was little original thought. Such studies should consider future needs not only review the past. To relax the grip of a national model, as in the US, is progress. To encourage one where there was none before, in the name of consistency, is likely to stifle the individuality that would lead to speed and efficiency.

Epilogue

THERE HAVE BEEN tremendous advances during the twentieth century, educationally, socially and technologically. All these have been mirrored in personal writing, even more than in the changing school models. Looking at examples from around the world, it is surprising how little effect any of these models have on writing today. The anguish that many children experience, however, through the imposition of an inappropriate model before they grow old or brave enough to discard it, cannot be measured. So why are the distinctive features of national, or even school models considered to be of such importance, and sometimes the only thing considered? Children need some kind of model to begin with, but the best could be described as non-obtrusive, stressing movement but allowing most scope for personal variation. This is because the writing of the future will need to be suited to the individual's character and body movements. What they do naturally will suit their hand, be it rounder, narrower, straighter or more slanting than the model, and be most consistent. What they do most comfortably will speed up most easily and evolve into efficiency through personal joins and short cuts.

The writing of the future may well contain more, readily understood abbreviations or iconic elements. One thing is certain, the changing usage of handwriting must be taken into consideration if any future policy is to be successful. Planning should start with the final product – the kind of writing a school leaver needs – and then educationists should work backwards to achieve this. Where enough computers are available, one solution might be to teach infants to record their thoughts first on the screen, leaving handwriting until their co-ordination is better. Unfortunately, intelligent children would inevitably experiment by themselves, leaving teachers the far more difficult task of correcting the movement of their letters. So it is back to the issue of the training of teachers, to ensure they have a command of methods that instill the essentials as quickly as possible, making learning to write as painless as possible for all concerned. More than that would be foolish to predict.

A technology more portable and flexible than the pen is not yet in sight. A possible compromise may be the scanning of handwriting. This would combine the productive convenience of the pen with the legibility of the printed word. Whatever the outcome, tomorrow's children are still likely to need their handwriting for the forseeable future, though exactly what form it will take in another hundred years is anyone's guess.

References

Anderson R (1990) *Spin a Woolly Yarn*. Self-published. Iron Knob, South Australia.

Anon (1872) *Reading Without Tears*. Hatchards, London.

Anon (1840) *Choix Gradué de 50 Sortes d'Ecritures*. Hachette, Paris.

Barchowsky N J (1997) *Fluent Handwriting*. Swansbury Inc. Aberdeen Maryland.

Barnard T (1968) 'Handwriting and Contemporary Education'. *Journal of the Society for Italic Handwriting*, number 54.

Barnard T (1979) *Handwriting Activities*. Ward Lock Educational, London.

Barnard T (1989) *Write Away*. Philip and Tacey, Andover, UK.

Barnard T (undated) *An Introduction to Firsthand Writing, Cursive Writing, Round style Writing and Italic Writing*. Leaflets for Platignum, Stevenage, UK.

Barry P (1954) *Handwriting Sheets*. James Barrie, London.

Barry W F (date unknown) *The Hygiene of the Schoolroom*. Silver, Burdett, and Co, New York.

Baudin F and Dreyfus J (1973) *Dossier A-Z*. Association Typografique Internationale.

Bjerkenes A (1961) *Form-skrift*. Tiden, Oslo.

Bjerkenes A (1976) *Formskrift*. Tiden Norsk Forlag, Oslo.

Bjerkenes A (1986) *Vi Former Skrift*. Tiden Norsk Forlag, Oslo.

Bjerkenes A and Clemens C (1976) *Formskrift*. Grafisk, Copenhagen.

Blunt W (1952) *Sweet Roman Hand*. James Barrie, London.

Blunt W (1955) *Handwriting A Practical Approach to the Italic Hand*. James Barrie, London.

Blunt W and Carter W (1954) *Italic Handwriting*. Newman Neame, London.

Briem G SE (1988) *Italíu-skrift*. Second Hand Press, London.

Bridges M M (1899) *A New Handwriting for Teachers*. Oxford University Press, Oxford.

Bridges R (1927) *English Handwriting, Tract XXVIII*. Clarendon Press, Oxford.

Bright J and Piggott R (1976) *Handwriting a Workbook*. Cambridge University Press, Cambridge.

Brown F (1985) 'Teaching Handwriting in an English Inner-city Area'. *Journal of the Forensic Science Society*.

Brown J (1972) 'Cursive Handwriting'. *Journal of the Society for Italic Handwriting*, number 73.

Brown R (1992) *Ginn Handwriting*. Ginn, Aylesbury.

Callewaert H (1962) *Graphologie et Physiologie de L'Ecriture*. Nauwelaerts, Louvain.

Cambridge J and Anderson E M (1979) *The Handwriting of Spina Bifida Children*. ASBAH (The Society for Spina Bifida and Hydrocephalus), London.

Canfield-Fisher D (1913) *A Montessori Mother*. Constable, New York.

Carstairs J (1836) *Lectures on the Art of Writing*. London.

Carstairs J (1887) *New Compendium Of Penmanship*. London.

Carter W (1973) 'Notes on Letter-carving'. *Dossier A-Z*. Association Typographique Internationale.

Chapman P (1990) *The New Cursive Handwriting Guide*. Berol, King's Lynn, UK.

Clark M M (1974) *Teaching Left-handed Children*. Hodder and Stoughton, London.

Clemens C (1989) *Bedre Hand Skrivning*. Ashehoug Dansk Forlag, Copenhagen.

Cripps C (1995) *A Hand for Spelling*. LDA, Cambridge.

Davis A and Ritchie R (1996) *THRASS*. Collins Educational, London.

Downing J (1964) *The Initial Teaching Alphabet*. Cassell, London.

Dumpleton J le F (1954) *The Art of Handwriting*. British Pens Ltd, London and Birmingham.

Eriksen T B (1993) *Form-skrift. Bokspor: Norsk* Bøker *Gjenom 350 År*. Oslo Universitet Forlaget, Oslo.

Eager F (1967) *The Italic Way to Beautiful Handwriting*. Collier Books, New York.

Fagg R (1962) *Everyday Handwriting, Six Books*. Hodder and Stoughton, London.

Fagg R (1982) *Handwriting Books 1 and 2*. Hodder and Stoughton for W H Smith, London.

Fagg R (1987) *Handwriting Book*. Hodder and Stoughton for W H Smith, London.

Fagg R (1990) *Helping Left-handed Children to Enjoy Handwriting*. Anything Lefthanded Ltd, London.

Fagg R (1992) *Handwriting Practice*. Hodder and Stoughton, London.

Fairbank A (1932) *A Handwriting Manual*. The Dryad Press, Leicester.

Fairbank A (1946) *A Book of Scripts*. Penguin Books, Harmondworth, UK.

Fairbank A (1958/9) *Beacon Writing Books Five and Six*. Ginn and Co Ltd, London.

Fairbank A (1970) *The Story of Handwriting*. Faber and Faber, London.

Fairbank A and Stone C (1961) *First Supplement to Beacon Books One and Two*. Ginn and Co Ltd, London.

Fidge L and Smith P (1970) *Nelson Handwriting*. Thomas Nelson and Sons Ltd, London.

Fry R and Lowe E A (1926) *English Handwriting*. Clarendon Press, Oxford.

Getty B and Dubay I (1991) *Write Now*. Continuing Educational Press, Portland State University, Portland, Oregon.

Gordon H (undated) *Handwriting and How to Teach it*. Marshall, London.

Gordon V E C and Mock R (1960) *Twentieth Century Handwriting*. Methuen, London.

Gourdie T (1967) *A Guide to Better Handwriting*. Studio Vista, London.

Gourdie T (1968) *The Ladybird Book of Handwriting*. Ladybird Books Ltd, (Wills and Hepworth), Loughborough, UK.

Gourdie T and Atkinson D (1974) *I Can Write*. Macmillan, London.

Gourdie T (1975) *Improve Your Handwriting*. A and C Black, London.

Gourdie T (1981) *Learning to Write*. Macdonald, Edinburgh.

Gray N (1976) 'The Teaching of Writing in Schools'. *The Report of Working Seminar on the Teaching of Letterforms*. Association Typographique Internationale.

Gray N (1979) 'Towards a New Handwriting Adapted to the Ballpoint Pen', *Visible Language XXIII no 1*.

Gray W S (1956) *The Teaching of Reading and Writing*. UNESCO.

Gunn J (1916) *The Infant School*. Thomas Nelson and Sons Ltd, London.

Hawley R (1966) 'Handwriting in Schools, parts one and two'. *The Journal of The Society for Italic Handwriting*, numbers 46 and 47.

Heal A (1931) *The English Writing Masters and their Copy-books*. Cambridge University Press, Cambridge.

Hewitt G (1916) *The Oxford Copy-books, Books 1 and 2*. Oxford University Press, Oxford.

Hewitt G (1938) *Handwriting, Everyman's Craft*. Kegan, Paul, Trench and Trübner, London.

Hewitt G (1930) *Lettering*. Seeley Service and Co, London.

Hooper W and Fairbank A (1958) *Beacon Book Four*. Ginn and Co Ltd, London.

Hooton M (1983) *Basic Handwriting*, Longman.

Inglis A, Connell E and McIntosh D M (1962) *The Teaching of Handwriting, Infant Work Books A and B and Infant Teaching Manual*. Thomas Nelson and Sons Ltd, London.

Inglis A, Gibson E H and McIntosh D M (1962) *The Teaching of Handwriting, Work Books 1-4 and Primary Teacher's Manual*. Thomas Nelson and Sons Ltd, London.

Jackson D (1981) *The Story of Writing*. Studio Vista, London.

Jackson W J and Michael B (1986) *Foundations of Writing*. Scottish Curriculum Development Service, Edinburgh.

Jarman C (1979) *The Development of Handwriting Skills*. Basil Blackwell, Oxford.

Jarman C (1982) *Handwriting Skills*. Basil Blackwell, Oxford.

Jarman C (1993) *The Christopher Jarman Handwriting Scheme*. Stanley Thornes, Cheltenham, UK.

Jean G (1992) *Writing. The Story of Alphabets and Scripts*. Thames and Hudson, London.

Johnston E (1906) *Writing, Illuminating and Lettering*. John Hogg, London.

Johnston E (1909) *Manuscript and Inscriptional Letters*. Sir Isaac Pitman and Sons, London.

Johnston P (1959) *Edward Johnston*. Faber and Faber, London.

Hooton M (1983) *Basic Handwriting Books* 1-4. Longman, Harlow, UK.

Kerr J (1916) *Newsholme's School Hygiene*. George Allen and Unwin, London.

Kimmins C W (1916) 'Handwriting'. *Child Study*, June.

Kindersley L (1993) *Oxford Handwriting Practice*. Oxford University Press, Oxford.

Kutiné S T and Virávölgi P (1976) *A Maci Ir*. Tankonykiado, Budapest.

Kutiné S T and Virávölgi P (1985) *A Maci Ir*. Iparmuveszeti Foiskoia, Budapest.

La Cour I (1984) *Skriv Tydeligt*. Aschehoug, Copenhagen.

Lindegren E (1976) *An ABC Book*. Pentalic, New York.

Lloyd S and Wernham S (1993) *Finger Phonics*. Jolly Learning, Chigwell, UK.

Mandal A C (1982) 'The Correct Height of School Furniture'. *Human Factors* 24 (3), and *Physiotherapy* (1984) vol 70 no 3.

McNeill M (1971) *Vere Foster 1819-1900, An Irish Benefactor*. David and Charles, London.

Mee A (1909) *Children's Encyclopaedia*. Carmelite House, London.

Mee A (later edition c.1923) *Children's Encyclopedia*. Educational Books, London.

Mercator G (1540) *Literarum Latinarum quas Italicas Cursoriasque Vocant, Scribendarum Ratio*.

Meulenbroek R (1989) *A Study of Handwriting Production*. PhD thesis published by the University of Nijmegen.

Meyrat P (undated) *Recueil Méthodique de Principes d'Ecriture*. Brégéras, Limoges.

Michael B (1978) *The Letterforms Kit*. Jordanhill College of Education, Glasgow.

Mock R (1955) *Principles of Art Teaching*. University of London Press.

Mock R (1973) 'Excerpts from Twentieth Century Handwriting'. *Dossier A-Z*, Association Typographique Internationale.

Morison S (1951) *American Copybooks*. W Fell, Philadelphia.

Morrigi S N and Arnesen J R (1982) *Arbeidshefte Skriftforming*. Aschehoug, Oslo.

Morse P (1987) *Handwriting Copy Book. Part of Teaching Reading and Spelling*. Learning Difficulties Project, Kingston Polytechnic. TRTS Publishing, Wrexham, UK.

Mulhaüser A M (1842) *A Manual of Writing (adapted to English Use)*. Parker, London.

Murdock H Y and Berry G (1988) *Learn to Write*. Ladybird Books, Loughborough, UK.

National Writing Project Newsletter, No 2 Spring (1986) *About Writing*. Schools Curriculum Development Committee, London.

Odman A (1987) *Min Skrivstil*. Svenska Läromedel. Esbo, Sweden.

Oftedal K (1983) *Skriftbok*. Gyldendal Norsk Forlag, Oslo.

Osley A S (1980) *Scribes and Sources*. David Godine, Boston.

Paull M and Haskell P (1977) *My First Writing Book*. ESA, Harlow, UK.

Phillips R C (undated) *Readable Writing*. R C Phillips, Oxford.

Phillips R C (1976) The Skill of Handwriting. R C Phillips, Oxford.

Piggott R (1958) *Handwriting a National Survey*. George Allen and Unwin, London.

Regnier Ainé (undated) *Méthode Générale d'Ecriture*. Pigier, Paris.

Reynolds L R (1972) *Weathergrams*. Society of Italic Handwriting, Reed College, Portland, Oregon.

Richardson M (1935) *Writing and Writing Patterns*. University of London Press.

Rowlandson J (1961) *First and Second Steps, Script Writing Books*. Philograph Publications, Andover, U K.

Rusk R R (1912) 'Position of Copybooks'. *School World*, Oct.

Sassoon R (1983) *The Practical Guide to Children's Handwriting*. Thames and Hudson, London. Revised edition (1995) Hodder and Stoughton, London.

Sassoon R (1986) *Helping Your Handwriting* (in two volumes) Arnold Wheaton, Leeds. Republished (1994) as *Helping With Handwriting* (in one volume). John Murray, London.

Sassoon R (1990) *Handwriting the Way to Teach it*. Stanley Thornes, Cheltenham. Revised edition (1995) Leopard Learning Ltd, Bath.

Sassoon R (1990) *Handwriting a New Perspective*. Stanley Thornes, Cheltenham. Republished (1995) Leopard Learning Ltd, Bath.

Sassoon R (1993) *The Art and Science of Handwriting*. Intellect, Exeter, UK.

Sassoon R (1995) *The Acquisition of a Second Writing System*. Intellect, Exeter, UK.

Sassoon R and Briem G SE (1984) *Teach Yourself Handwriting*. Hodder and Stoughton, London.

Sentman E E (ed.) (1936) *The Junior Instructor*. United Educators Inc. USA.

Shelley J (1913) In *The Demonstration School Record no 2*, edited by J J Findlay. Manchester University Press, Manchester.

Steele R (1932) *The Script House*. Frederick Warne, London.

Stokes W (1878) *Stokes' Rapid Writing*. Houlston and Sons, London.

Stone C and Fairbank A (1957) *Beacon Handwriting Books One and Two*. Ginn & Co, Stevenage, UK.

Swift J (1986) 'Marion Richardson and the Mind Picture', *Canadian Review of Art Education Research*. Canadian Society for Education Through Art.

Taipale D (1982) *Italic Handwriting*. Westwind Graphic Design, Great Falls, Montana.

Tanner R (1952) 'Left-handedness in Writing'. *Athene, Journal of the Society for Education in Art*. Handwriting number, November.

Tarr J C (1952) *Good Handwriting and How to Acquire it*. Phoenix House, London.

Taylor J (1973) *Reading and Writing in the First School*. Unwin Education, London.

Thomas D (1918) *Handwriting Reform*. Thomas Nelson and Sons, London.

Thomas G L (1954) *Better Handwriting*. Penguin Books, Harmondsworth.

Thompson M E (1911) *The Psychology and Pedagogy of Writing*. Warwick and York.

Thornton T P (1996) *Handwriting in America*. Yale University Press, New Haven and London.

Thurber D N (1978) *D'Nealian Handwriting*. Scott Foresman, Glenview, Illinois.

Thurber D N (1993) *D'Nealian Handwriting*, third edition. Scott Foresman, Glenview, Illinois.

Twyman M (1996) 'Lectures Manuscrites. School Books Designed to Give Children Experience in Reading Handwriting', *Information Design Journal* 8 (3).

Wallis Myers P (1983) 'Handwriting in English Education'. *Visible Language* XVII No 4, Autumn.

Wellington I (1955) *Handwriting Copy-books*. James Barrie, London.

Welpton W P (1908) *Principles and Methods of Physical Education and Hygiene*. Clive and Co, London.

West A (1951) *Written by Hand*. George Allen and Unwin, London.

Whalley I J (1975) *Writing Implements and Accessories*. David and Charles, London.

Wilkins J (1992) *A Child's Eye View 1904-1920*. Book Guild, London.

Wood P (1953) *Italic Handwriting for Schools*. E J Arnold, Leeds, UK.

Worthy W (1954) *The Renaissance Handwriting Books*. Chatto and Windus, London.

Yates-Smith K C (1953) *Italigraph Handwriting*. Philip and Tacey, Andover, UK.

Index